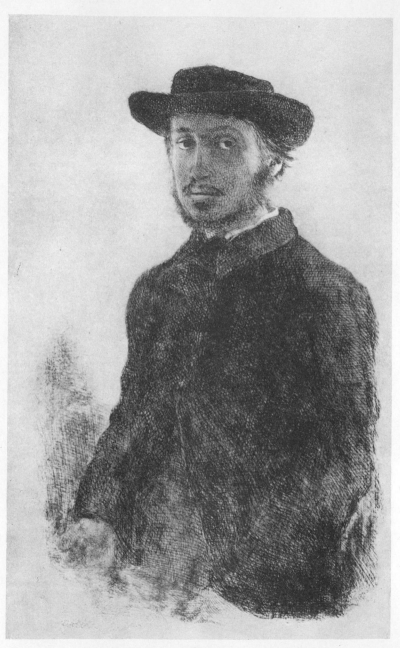

Self-Portrait. Etching (final state), 1857.

DEGAS

by Julius Meier-Graefe

Translated by J. Holroyd Reece

DOVER PUBLICATIONS, INC.

NEW YORK

This Dover edition, first published in 1988, is an unabridged, slightly
corrected republication of the text of the work as published by Alfred A.
Knopf, New York, in 1923 (original English edition: Benn Brothers,
Ltd., London, 1923). Of the 103 plates that appeared in that edition, 41
are here reproduced.

Manufactured in the United States of America
Dover Publications, Inc., 31 East 2nd Street, Mineola, N.Y. 11501

Library of Congress Cataloging-in-Publication Data

Meier-Graefe, Julius, 1867–1935.
 Degas / by Julius Meier-Graefe : translated by J. Holroyd Reece.
 p. cm.
 "Unabridged, slightly corrected republication of the text of the
work as published by Alfred A. Knopf, New York, in 1923."
 ISBN 0-486-25702-9 (pbk.)
 1. Degas, Edgar, 1834–1917. 2. Artists—France—Biography.
I. Title.
N6853.D33M45 1988
759.4—dc19
[B] 88-14956
 CIP

List of Illustrations

IN SENDING the translation of Degas to press I cannot resist the temptation to say a few words to the readers and critics of the English version of *Vincent van Gogh*. The warmth with which my efforts to render a great work of art accessible to English readers were received, was the source of great pleasure to Mr. Meier-Graefe and to myself. I was interested to find that a number of critics commented upon the possibly unorthodox method of translation adopted. In the case of the van Gogh I virtually committed the original to memory and wrote the earlier drafts without reference to the original text. I was sufficiently encouraged by the references made to this method to make the same attempt in translating the Degas. The manner of Mr. Meier-Graefe's book on Degas does not, however, lend itself to such treatment. The great merits of the present volume depend upon the author's powers of critical analysis, and I was not therefore confronted primarily with the problem of finding an equivalent in English prose for specific literary values. In making the present translation, I conceived it my duty rather to concentrate upon the precise rendering of the author's thought than upon any attempt to guess at the style Mr. Meier-Graefe might have adopted had he been writing in English. The style of the German text is simply the outcome of the assertive force of the author's thought, and, probably for lack of stylistic powers of my own, I decided that I could best serve the interests of the author and his English readers by placing my trust in the sense which the English equivalent of the German text conveys.

Shortly after the publication of the English version of *Vincent van*

Gogh, I received a number of letters, mostly from correspondents unknown to me personally, pointing out small errors of various kinds. I do not think that most people are sufficiently aware how welcome such corrections are. Several changes of ownership of pictures by Degas will appear in the present volume. For these I am indebted to Mr. Louis F. Fergusson.

There now remains the pleasant task of recording my gratitude to those who have helped to eradicate the worst of my errors in the translation. Mr. R. R. Tatlock has contributed a number of valuable suggestions which have elucidated the meaning of obscure passages, and he has been my careful helper in reading the proofs. As in the case of *Vincent van Gogh,* I owe the best passages in the English version to the continuous and painstaking assistance of my wife.

17 Gayfere Street, J. HOLROYD-REECE
Smith Square, S.W.1

THE OLD MAN wore a wide circular cloak, rather shabby but scrupulously clean. He used to take a tram every day from Montmartre to some quarter of Paris. There he would descend and enter another car. He did not care where he went. The old man sat motionless. When the conductor appeared, he pulled out his sous rather hastily but without looking. He did not read in the tram as the others did; he looked straight over the head of whoever happened to sit opposite to him. He never said a word to anyone and no one greeted him.

"Rum chap!" said the conductor to his colleague at the terminus. In French there are many expressions to describe queer people, and tram conductors have a variety of their own.

In the afternoon his cloaked figure descended the Rue Lafitte from Notre Dame de Lorette. He had known every stone in the street for the last half-century. The old man walked slowly, guiding his cloak carefully through the throng of people, and seemed more intent than others upon evading contact with his fellows; for this very reason, he was less successful than the bolder spirits who slipped in and out with fish-like agility. Every now and again he stood still, swaying a little. He was a curious spectacle among the fleet-footed passers-by, who appeared to spend most of their time in the streets. He looked almost as though his centre of gravity was stationary while his limbs moved onwards. He carried his head immobile through the crowd. His eyes were fixed, looking up a little, like those of a blind man. Sometimes his expression became rigid and his whole appearance suggested the mysterious giants, whose motionless masks were borne aloft on high

poles, covered with enormous flowing mantles, during Carnival in Spain.

He was a stranger, although everyone knew him, and although he had fingered each door-handle in the Rue Lafitte a hundred times. Impenetrability was the cloak he wore. When he entered a house everyone moved shyly to one side, while his host advanced somewhat uneasily to offer him a respectful welcome. Behind the counters in shops, the assistants put their heads together and in whispers exhausted the range of the French vocabulary for "rum chap." In the Rue Lafitte he was referred to in an undertone, and always in quite a peculiar way.

During the auction sales at the Hôtel Drouot he sat there, a motionless figure, and everyone was surprised to see him share a bench with other people. He looked like a carved figure of the Quattrocento. The last time I saw him was at the Vente Rouart, when his pictures drove the buyers to the verge of madness. His presence in the room was more interesting than his pictures. The other day, while a new revolution ravaged Russia, the papers announced that he was dead.* Everything he did was calculated to avoid publicity. Only a handful of mourners followed his coffin.

One of my Italian acquaintances in Paris assured me that he had sometimes spent a few pleasant hours with the old man, but only when he spoke Italian. Italian spoken with a Neapolitan accent was almost his mother-tongue. Anything which recalled the youth he had spent in the South caused an occasional ray to illumine his graven features. As a Frenchman, he was anything but gay. His laughter had an edge of steel. Anyone who was made to feel it went about afterwards like a wounded animal. The few contemporaries who still survive him become silent at the mention of his name. I am quite sure that even to-day, after his death, they are no less shy of the subject. From the day the two brothers Rouart disappeared, he was friendless. Henri Rouart used to speak of him most affectionately, and insisted that the popular conception of him was quite false. If, however, Henri Rouart was requested to say what he really was like, the kindly old gentleman would become restive and change the subject.

When the Dreyfus case was at its height, this mysterious painter broke with everyone who was not bitterly hostile to the victim, and

*He died in Paris on September 26, 1917, at the age of 83, and was buried in the cemetery of Montmartre.

from that time onward he withdrew from the world about him altogether. Had he better reasons than Zola, whom he chastised with his bitter tongue? He had the only possible reason: he wished to be so. The Dreyfus case was for Zola and his friends a more or less legitimate opportunity to get into closer touch with their fellow-men; for Degas, although he sided with the majority, it was a certain means of increasing the distance between them and himself. He never gave five minutes' thought to the justice of the case, and he was far from associating himself with those who agreed with him. He acted merely on an obscure impulse which sprang from negations. He frequently acted thus.

Such was the man who had an inborn hatred of his fellows, and who became an artist. His strange and wild revulsions undoubtedly concealed a form of idealism, for otherwise it would be hard to explain his choice of career, no matter what he achieved in it. He was a romantic—a negative romanticism which dried up and turned against the world, ultimately against himself. He once told Renoir that he was himself his own worst enemy—a statement which is yet another proof of his romanticism. His art is the fruit of it, and of his fanatical hatred of humanity.

It sounds improbable. The work of no painter is more fecund with the life that surrounded him. No man's pictures are so full of actual events. Nevertheless, it would be wrong to ascribe the relationship of the painter with the people he portrayed to any sense of human participation. Nor can his painting be ascribed to the usual causes that give birth to creative art.

Even his earliest work is untouched by any breath of warm humanity, but rather the offspring of a formula. His early work is so impersonal that it is difficult even to associate the name of a teacher with it. Possibly Ingres, who was perhaps the only man whom Degas ever loved, and possibly Poussin. All personal relationship with a master is missing. He did not learn from Ingres that specific quality which is capable of development; he acquired the tricks of the school, the Academy. Every modern master has struggled against tradition. Convention is the first object of their antagonism. All of them, since Delacroix and Corot, began as revolutionaries, even if they were less anarchic than the youthful Cézanne, even though we fail to recognise the distance they have travelled away from their inherited convention, because we only perceive the new convention they themselves created. In all of them emotion is uppermost. They feel themselves and want

to feel. We want this and that, they say. Nebulous aspirations. They are unable to formulate, they stutter, are soft, chatty, sentimental, crude, intentionally vague, like all young people. But they bring something new—more or less new. They have come to tell the world about it. Even Corot makes us feel something of the kind, although the mantle of his school is wrapped about him so closely.

The situation is the same to-day. The choice is not made by the master, the teacher, or any outside individual, but is determined solely by the emotional vigour of the artist himself—"I must paint, for I lack every other means of expression." Emotion means school, technique, artistic descent. Art only begins later on when the first foam of subjectivity has evaporated. And then emotion counts more than ever and the question is: Is it strong enough to be the mortar for the myriad stones supplied by the outer world? Is his originality capable of building anew upon the old foundations? Will he become more and more original? The old only determines the validity of the new element, and the goal is attained when art and emotion are fused.

Such was the art of Delacroix. His emotion was strong enough to assimilate every value, a complete cosmos. His art, filled to over-flowing, was set in motion, trembled and responded to every breath of feeling. We do not perceive the boundary line between emotion and art, nor between the old and the new. It is all the creation of his mind, and it is about us and becomes part of us, like our consciousness of the earth and the sky, of trees and of stones.

His successors longed to emulate him. Not one of them succeeded. Their work remains a swaying compromise between emotion and art. But we recognise related organisms: trees of rougher stock, gnarled coarsely where they should be smooth, of irregular proportions, having branches where there should be trunk, but trees. We bask in their shade as if it were sunshine. Emotion is the creative sap in all of them, and it is possibly an excess of emotion which gives them their fragmentary character by the side of Delacroix.

Degas was different. He began differently and remained different. Nothing fragmentary, no compromise, completely enclosed in a shell. But not a tree, anything but that, rather a cloak, sufficient for himself and not for others. Did Degas lack emotion? Let it not be supposed for an instant. Excess of emotion, perhaps, made him incapable of giving out what was in him. Possibly he loved so fanatically that he arrived by necessity at hatred. A pitiable old man. He never had a youth.

Degas was not a pure Frenchman. The Revolution drove his grandfather, who belonged to an ancient French family,* out of his native France. He founded a bank in Naples and married an Italian. Certain members of the family still live there. The father of the painter, a born Neapolitan, came to Paris in his early youth and founded a branch of the Neapolitan banking firm in the Rue St. Georges. The branch is said to have been a failure. He had artistic leanings. Edgar-Hilaire-Germain Degas was born in Paris, the eldest of three sons, on June† 19, 1834. His mother was a native of New Orleans, and was a Creole of French descent. The Degas family owned a cotton factory in New Orleans which traded under the name of Degas Brothers. Edgar Degas had an interest in the concern.‡ Two of his brothers and an uncle of the painter managed the business. Edgar went over there in 1873, and he painted the office of the factory, as well as his uncle and his brothers.

Can the strangeness of Degas' art be traced to his descent? It is true that no one knew certain sides of Parisian life better than he did. Many of his pictures are commentaries on the manners of his age. An outsider often has the keenest eye for the peculiarities of his surroundings. This curious faculty of Degas, the observer of a particular world, might be proffered as evidence that he remained a stranger in the realm of art.

He began as a well-intentioned pupil who might just as well have become a barrister. Huysmans committed an unintelligible error in calling Delacroix his real master, probably because Degas developed into a colourist later on. Huysmans overlooked the fact that colour was for Degas only a substitute, and it will never be anything else in his work. Degas became a connoisseur of good pictures and he acquired, when he had sufficient means, fine works by Delacroix. They interested him like the movements of his dancers and his horses, but nothing was more alien to his instinct. At bottom, he despised the whole manner of Delacroix's work, and he has not scrupled on occasion even to confess it. Everything that was wrested from emotion was vulgar in his sight. Ingres, who decided him to become an artist,

*The family name was De Gas. Degas sometimes used the old spelling in signing early pictures.

†[July].

‡Dr. Reinhart, of Winterthur, told me so. Reinhart's firm were agents for Degas Brothers. The painter in his early youth once accompanied his brothers on a business visit to Winterthur.

was his master. As he could not study under him personally, a fact he never ceased to lament, he entered the Ecole des Beaux-Arts under Lamothe, the unhappy pupil of Ingres,* in 1855. There he was with, amongst others, the draughtsman Serret, who has left some delicate drawings. Ingres always remained his ideal. He never forgave himself because he failed to subject his work completely to his influence. He blamed the age in which he lived for it, and hated it accordingly. The peculiarities of his own work, which became evident later, were, in his judgment, execrable.

According to Lemoisne,† he had already exchanged the Ecole des Beaux-Arts for Rome in 1856. His first pictures are single classical figures, which at a distance are reminiscent of Poussin; for instance, La Femme au Châle Jaune, belonging to Durand-Ruel, or the Mendiante Romaine in the Decape collection. These pictures differ from hundreds of schoolpictures of the period only in the coarseness of their detail. The pupil was more severe than the master. In the early works we find none of the boldness of Ingres' compositions, much less anything of the picturesque rhythm softened by gentle colour-schemes which reconciles us to his most amazing inventions. Degas' canvases are composed of modelling and line, but in stone. His colour seems to exist only for ethnographic differences. Many German artists of the period painted in a similar way. Like the German and the French classicists, he saved himself by his portraiture. According to Lafond he painted a number of portraits‡ in Italy. The portrait of himself dated 1857 has been preserved and possesses great charm in the reproduction (I do not know the original); it seems plastic, picturesque, very convincing in its expression, not unlike a Chassériau. He drew a great deal in Rome after Mantegna and the early Florentines as well as from Nature.

In 1856 he made etchings, portraits of his friend Fournay the painter, and also of Fournay's sister. In 1857 he produced the portrait of an old gentleman in a cap and spectacles (M. Brandon), and probably also that of the Princess Wolkonsky. They were not the revelations of a visionary, but they were admirable etchings. We experience, for the first time in his work, what is so rare in Frenchmen

*To be exact, Lamothe was a pupil of Flandrin, but under the personal influence of Ingres.

†Author of a small monograph on Degas which appeared shortly before the War. (Librairie Centrale des Beaux-Arts. Paris, n.d.)

‡Paul Lafond: Degas (H. Floury, Paris, 1918).

La Femme au Châle Jaune. Oil, 1857.

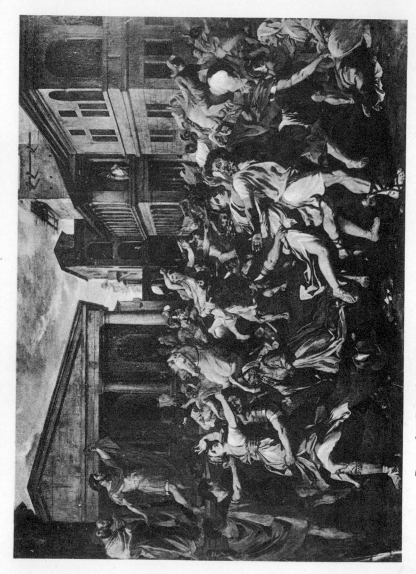

Copy after Poussin's *L'Enlèvement des Femmes Sabines*. Oil, ca. 1870.

of this period: he becomes another man as soon as he exchanges his brush for a crayon or the needle. His efforts gain in substance. What was cold and harsh in his pictures becomes sturdy professionalism in his etchings. The artist feels himself at home. In Rome he etched a pendant to his painted portrait of himself, the melancholy youth with the large eyes. His hand was still so unpractised and halting that it is almost possible to imagine that the etched portrait dates back further than the painted canvas. The features of the curious face could still be discerned in the wrinkled countenance of the old man.

He returned to Paris as a fully-blown anecdotal painter. A certain chill emanates from the earliest of his big compositions. The *Jeunes Filles Spartiates provoquant des Garçons* dated 1860, a collection of nude figures of both sexes, and *Sémiramis construisant une Ville* dated 1861 (I only know the last-named from a reproduction) seem like the academic efforts of a painter who pursues his calling like a worthy craftsman, without any ulterior motive.* Nothing but a certain hesitancy in some details, a clumsiness which trembles before complete realisation, offers a faint indication of the nobler inhibitions of the beginner. Once more the draughtsman comes to the fore. There are several pencil drawings of this period where he comes close to Ingres. Some of the studies for his classical canvases suggest a certain advance on the painter of the *Odalisque*. A number of them were made for the female figure which, in the picture of Semiramis, mounts the ancient chariot. In one chalk sketch her figure is clothed, in another in pencil she is nude.† The robed figure is a careful study of drapery made by a distinguished and eclectic student. The naked one is the first legitimate child of the master, graceful as Ingres, though never to be confused with him, because Degas' study is less classical, less pure, less rounded, although it is rich in fine curves. You cannot quite believe of the bold and well-raised foot that it would

*The following might also be mentioned in this connection: *Achille et le Bucéphale, Mademoiselle Fiocre dans le Ballet de "La Source,"* and the large canvas entitled *La fille de Jephte*. They were reproduced in the catalogue of the first vente *Atelier Edgar Degas* (auction, May 6–8, 1918). The picture of Semiramis referred to above was also included in the sale, and was acquired by the Musée du Luxembourg. A picture referred to as *Jeunes Spartiates s'exerçant à la lutte* also appeared in the catalogue and several studies for these pictures were included in the sale. Compare also the catalogue of the second vente (December 11–13, 1918).

†Both these drawings are admirably reproduced in a folio entitled *Album de vingt dessins*, published some years ago by Manzi Joyant et Cie (Goupil, Paris). Other drawings of this period appeared in Lafond's publications. Facsimiles of later drawings were issued in the *Skizzenmappe* of the Marées Society.

ever ascend an ancient chariot. In reality, the pert little minx is mounting a Parisian stage, is stepping into our own world. The charm of the drawing does not conceal the self-conscious assumption of the grisette in her. The vague profile suggests all kinds of things which do not belong to the stock-in-trade of a genre-painter.

In Paris he continued his study of the old masters. The Louvre, which was the common hunting-ground for the younger generation, became his temple. He made copies of innumerable pictures and drawings, after Mantegna, Poussin, Holbein's *Anne of Cleves*, the so-called Giorgione *Holy Family*, and he painted the little black picture in the Durand-Ruel collection after a mezzotint by Lawrence.* His copies are clues to a number of problems. The weakest of them all, and, therefore, probably the earliest, is his copy after Holbein. Degas made an attempt at simplification, and it would be possible, by sacrificing verisimilitude to the detail of drawing in the original, and by means of an all-embracing wealth of richly-toned colour. The attempt was unsuccessful because the painter in him failed. Degas had counted on his draughtsmanship, and what he failed to give in detail of drawing he did not compensate for by sufficient breadth of brushwork. The black and patternless tones in the thin flesh of the face are at war with the surrounding fairness, which forms the whole basis of the concept. The hands are drawn even more carefully than those in the original, they are modelled most painstakingly, but they give to the picture an air of excessive frailty which does not belong to it. The simplifications in the dress are purely negative. In the picture in the Louvre you feel substance beneath the regal splendour, in all the countless flounces and laces. The variety of material only enriches the vibrating golden shimmer— the golden haze about her fairness—which is the picture's chief beauty. To imitate the gold, Degas only produced pale strokes of yellow, and this humble substitute fails even to achieve that unity which preserves the magnificence of Holbein from being lavish, by the certainty of its every detail. Apparently Degas did not regard his copy as complete, but he left the canvas unfinished, like his copy of the Mantegna in the Louvre, which remained in his possession right to the end.

His success is the more brilliant, although probably much later, in

*Many of these copies are of a later date. He copied enthusiastically in the 'seventies. His copy of Mantegna's *Crucifixion* was sold at the first auction after his death.

his copy of Poussin's *Rape of the Sabine Women*. The copy hung for many years in the studio of his friend, Henri Rouart, who left it to his daughter. According to his own statement, Degas expended six months of concentrated effort upon it, and he succeeded in producing a faithful rendering of this wonderful picture. His copy is almost literal. He contented himself with reproducing the colouring without the dirt that has clogged the original. Degas' picture does not, perhaps, possess the full splendour of the original, but in time his canvas may acquire it. His technique, at any rate, resembles Poussin's closely. In the drawing, you feel slight differences, which are scarcely detrimental to Degas, for instance, the expression of the loveliest figure, the armoured girl on the left in a blue dress, seems more youthful. The old woman on the extreme right has also been changed a trifle. His minute attention to every detail has scarcely taken any of the fresh bloom from the picture, and the rhythm of the swaying masses is almost as free as in the original. His reverence prevented him from making any attempt to give a new form to his own rendering of the general impression.

This copy was probably very useful to Degas. He was enchanted by the plasticity of moving masses, by the pure sound of coloured chords which no spontaneity can obliterate. Poussin's spirit seems to have inspired the pupil of Ingres with the subjects for his genre paintings. He probably owed to the same source the cool scepticism with which he accepted the development of modern painting.

He remained an anecdotal painter for some time. In the salon of 1865 appeared a picture of a mediæval battle (*Les Malheurs de la Ville d'Orléans**), in which Lemoisne thinks there are traces of Delacroix. It seems hardly justifiable to me, unless quite superficial resemblances are accepted. The nude figures in this picture reveal, for the first time, the painter's preference for bold attitudes in his models. At any rate, there is a change at this period, which is already perceptible in the earlier portraits of his friends, Bonnat, Moreau, and others. The most remarkable pair are the two in the Musée Bonnat in Bayonne. They are curious pictures, totally different from his early single figures, just as exaggeratedly soft as the early ones were dry and hard. There is a personal touch in them in so far as the red groundwork reveals a virile palette, which was wholly alien to the Ingres School.

*Also known under the title of *Scène de Guerre au moyen âge*, signed Ed. De Gas. Salon 1865 (catalogued as pastel). It was acquired at the first auction after his death by the Musée du Luxembourg, reproduced in the catalogue, also in Lafond's book.

Are they better? We are inclined to give a preference to every soft and plastic form and to ascribe a certain pictorial value to them which we like to deny to harder shapes. But these pictures do not seem soft to me, but effeminate. One might reproach these pictures with faulty drawing, though not of an academic kind. The nose, mouth and eyes are placed normally, but they are placed there without being constructed. The drawing is lost in the colour, and its function is not supplied by constructive brushwork. Especially the portrait of M. Melida, in the Museum of Bayonne, with its exaggerated red, makes an unbalanced and almost shapeless impression on the observer. You can at most see what the sitter looked like. The man in the picture, the painted equivalent which alone concerns us, has not been given an expression of his own.

CHAPTER

II

THE PORTRAITS of his early period, though they reveal the uncertainties of a beginner to a small degree only, reveal very little else. At the same time, they suggest that Degas had begun to doubt the ultimate validity of Ingres' formulæ. In a few pictures Degas began to grope his way towards a substitute. It would hardly be a mistake to ascribe his wavering to an influence which was felt by many talented people at the same time, although most of them belonged to a totally different school. Edouard Manet had caused a sensation in the Salon des Refusés in the year 1863, with the result that his work suddenly became known to a wide circle of artists. Other painters appeared on the scene side by side with Manet who were equally convinced opponents of the routine of the academicians. Thereby a new standing was given to Courbet, to whom all the younger generation looked for support. A new relation to nature made itself felt, simpler, more serious, more dependent on individual sensation, freer and at the same time more far-reaching. The tendencies of the age approached the spirit of the present day and recognised the necessity of breaking with the gospel of David, who tried to achieve greatness in art merely by the choice of noble subjects. The younger generation of the early 'sixties began to divine the thousand untried possibilities of a medium which was the expression of the age, and they came to recognise that by this medium alone they might enter into a fruitful relation to the old masters. Manet appeared as an innovator from the start: a man who cared nothing for fair phrases, and who set about his business from the beginning. Young painters were longing for a new

13

spirit, and their desire placed even Delacroix in the shade of Courbet for a short time, not without justification. Manet's call to the spirit of the age was an appeal to the genius of the race to free art from the fetters of amateurs, poets and philosophers. He wanted to identify painting with the direct expression of the national will, and he thereby made the last legitimate attempt to unite art and the nation— a new nation of his dreams. The main forces of the century, David, Ingres and the Romanticists, failed to satisfy the aspirations of the younger men, quite apart from the quality of their pictures; they seemed too artificial, too distant. The landscape painters of 1830 were too tame for them. Corot, whom they all revered, was too dreamy and too fatherly in comparison with the vision which they saw and longed for. One could almost ascribe to the *Déjeuner sur l'herbe*, as well as to the *Burial of Ornans*, a kind of tendenciousness, so foreign to the creator of the picture was the purely "arty" instinct to which they were heir.

The relationship of young Degas to these ideas is not altogether transparent. Nothing would be more erroneous than to accord to him the part that was played by Renoir, Monet and their companions. All revolutionary tendencies were alien to him. This was due, perhaps, to a personal revulsion against all forms of demonstration, or possibly to the fact that he did not feel or comprehend to the same degree the ideas which impressed his contemporaries. He hesitated. In 1865 he still belonged officially to the ill-defined camp of the opposition, he still drew in the style of Ingres, and he only decided slowly, and without much effect, to employ for his own ends certain results arrived at by Manet.*

This attitude made him at this time somewhat of an outsider, occupying a position akin to that of his friends, Fantin, Legros and Whistler. He also got to know Manet and the others, but they probably saw tendencies similar to their own in his work more readily than he did.

His compromise becomes apparent in his *Femme aux Chrysan-thèmes*. The influence of Manet and his friends can be clearly discerned in the flowers, though this influence hardly suffices to distinguish this still-life from the works of many other skilful

*He was never so close to Ingres as in the drawings which were made at the same time as these pictures. Compare, for instance, the pencil drawing of the young woman resting her head on her arms, dated 1865, which was reproduced in the above-mentioned folio *Vingt dessins*.

painters who followed after him. The portrait forced into the background reveals other traits. It is a dry piece of work, thin and feeble, revealing a superficial method of painting which is distinguished only by a little taste from the colour schemes of the Classicists. There is a dubious modern shade of expression in it—not so far removed from the mental anæmia of certain Englishmen of the same period. Degas, like many others, was at that time in danger of borrowing certain unessential characteristics from the new art of his day, in order to intensify his own style, which was ultimately genre-painting. He was a genre-painter of slightly superior traditions, employing restrained and well-chosen means, but none the less an artist whose work was separated by the widest gulf from all that Manet and his friends desired and achieved. By instinct, he belonged to the circle of Bonnat and Carolus Duran. One quality he lacked altogether: the irrepressible desire for confession, the inner compulsion from which Manet gave birth to his *Déjeuner*, Renoir his *Lisa* and Cézanne his black idylls. He lacked the longing of the creative artist who covers his nakedness with his canvas, and who finds his home and his existence in his painting. He never possessed the childish simplicity of such painters, the most essential attribute of an artist, and it was the lack of the same quality which prevented him from deriving immediate benefit from Ingres. For what would Ingres be, the Ingres of rules and systems, without the instinctive contradiction of his simplicity, which succeeded in overcoming all, or almost all, the narrow limitations of his doctrine? The pupils of Ingres stumbled in the dark because they inherited only the words of their master and not the inexpressible quality which is written between the lines. Painters who possessed talent susceptible of development, and who might have found scope for their abilities had they been under the sway of any other teaching, were suffocated by the régime of Ingres. You need to be a very great Romanticist to retain your individualilty in face of such hard-and-fast regulations. You need to be a Romanticist like Ingres himself, possessing a unique individuality, to be capable of giving life to your creations, with such heavy odds against you. Degas was too sober and unredeemed by heavenly follies. The compromise he attempted to make with Ingres was the first step he took towards Manet, and this step did not lack previous preparation. We can discover to-day in certain early Manets traces reminiscent of Ingres. We find them, too, in Renoir and we know what Cézanne thought of him; we recognise that the possibility

of contact is not precluded even between such distant spheres. Contact of this kind could never have been the result of conscious effort. Such contact is only conceivable when an impulse exists which emanates from some other and powerful third force; then, and then only, can these forces meet and fructify. The tendency of the youthful Degas to genre-painting, to which he had recourse by way of substitute, only impeded the progress of the painter. We shall see to what degree Degas succeeded in overcoming this trend in his nature. We do not discuss similar steps in the progress of other masters. It would be trivial, if not banal, to mention such things in connection with Ingres or Manet, nor can they claim any measure of praise for having overcome dangers which never existed for them. In their cases temperament, talent and instinct did for them what became the problem of a lifetime for Degas. As a rule, when once this nightmare, this tendency to genre-painting, becomes evident in the nature of an artist, it plays the part of a deadly inherited disease in his artistic life. In judging such an artist it will be necessary from the beginning to apply a kindlier standard of criticism in order to do justice to the effort of the individual. It is essential to bear in mind his fundamental attitude in order to avoid the confusion which can arise so easily in such cases, for the nature of the evolution of such a painter is peculiarly rich in the variety of his approaches towards his goal. The path of a Degas is comparable rather to the career of a politician than to that of an artist.

His love of genre plays its own part in his most important work of this period, the family picture painted in 1866 or 1867 which, like so many other early works, remained in the possession of Degas until his death owing to his seclusion from the world of art. This picture was hardly ever seen by anyone during his lifetime. Thanks to a fortunate accident I have been able to examine it once. The Louvre acquired it at the auction that took place after his death. The canvas is about eight feet long and six or seven feet high, and represents Degas' cousin, her husband and their two daughters, who were living in Naples at that time. The picture somehow cannot be called a genre-picture, for one is at a loss to find a story to fit it. All the figures are painted in simple postures. The chief figure, a lady in black, is made impressive by its simple dignity. The man with the red beard and fair hair seated before the fireplace with his back towards the observer is extraordinarily natural, and the children with their black clothes and greyish aprons are charming. There is nothing in the picture that can

fail to give pleasure. It possesses even very considerable and defin-
able artistic values, for instance, the Holbeinesque profile of the lady
in black and the charming interior effects which remind one of the
best Dutchmen. The chimney with its still-life, the green-blue wall
with the picture in its yellow-gold frame, everything, in spite of its
detailed representation, is in excellent taste. There is much art in
this picture, and yet it is impossible to get into close touch with it.
You do not know why it was painted; you ask what these people,
who are presented with the utmost skill, really signify. You search for
the genre, you attempt to discover some hidden tragedy or comedy,
you find nothing and are none the happier for it. Taking away the
story from a picture which calls for a literary interpretation is not
enough to make it into a work of art. It is not sufficient to paint an
interior and human figures with great skill. A higher and pictorial
purpose must appear, convincing as a legend, even though it is
impossible to formulate it as precisely as a legend may be put into
words.

You miss the mentality of the painter while he beheld this inte-
rior: you lack the reason why he painted it, why he painted it as he
did, and why he could not have painted it otherwise; you search in
vain for the creative impulse transformed into rhythm, which lends
to colour and to line a quality beyond the power of reproduction.
That the naturalism of such pictures does not repel us is due entirely
to the nature of the artist's choice of model. Whistler arrived at his
end by the same method. His production was on a lower plane,
because Whistler was more conscious of his activity. You see through
the mist of his pseudo-symphonies more quickly and recognise
with greater ease in his *Carlyle,* or in his picture of his mother, the
thinly-veiled skill of the illustrator. But no matter how far the
earnestness which Degas evinced at this time stands above the
lukewarm moods of the American, no matter how well Degas
succeeded in avoiding the fatal errors of the painter of *The Little
White Girl,* yet their kinship remains evident in his pictures. You
perceive a certain vacuity, which is due to insufficient organisation of
his artistic powers, and to insufficiently-developed subjectivity.
There is no adequate equivalent for the visual objects to create in
us the impression that the symbol he presented was his only
purpose.

In many other portraits made at the same time you feel the silence of
the story-teller in the midst of silent colour and line—a Fantin

without warmth.* His *Bouderie* of 1872—the fierce and sinister husband seated at the writing-table, arms crossed, refusing even to bestow a glance on his young wife—is a variation of a well-known theme practised by the lower grade of academicians, and Degas' employment of modern means does not make the attempt less distasteful.† It would be possible to write a very long chapter about the subject of the *Intérieur*, which went shortly before the War from Durand-Ruel to America, and which used to be called *Le Viol*, but there is nothing to be said about the artistic elements in the picture. Desboutin‡ the engraver, who is known by Manet's portrait, sat to Degas for his *L'Absinthe*, which was painted rather later, probably after Manet's *Café* pictures, that is to say about 1877. *L'Absinthe* possesses better qualities than the other pictures, and must be placed at the end of a period which was rich in failures. Degas almost succeeded in rendering what he has depicted objectively, and in removing the Bohemian existence, which he had observed so marvellously, to a higher plane. Almost! Think for a moment of the *Café* pictures of Manet, his precursor, who succeeded in a greater measure, and in whose pictures sodden expressions turned to luminous colour, and whose scenes, less detailed but no less honestly portrayed, stir forces which are mysteriously opposed to the *spiritus loci*. Manet could say with pride of his portrait of Desboutin that it was representative of Montmartre, and we may add—and, in spite of it, a work of art. We can never permit ourselves to add such phrases about Degas' pictures of this period. The observer cannot avoid the desire to look for things on the canvas which do not belong there. His narration as such is not the root of the evil. Corot, Daumier always had a tale to tell and we delight in it; even Renoir and many others are inconceivable without their inheritance from a talkative muse. In fact, can we conceive an artist who lacks the desire to relate something? Would not painting, without this communicative impulse, be at best a decorative play of coloured patches? It is not the lack of a story, but on the contrary, the lack of intensity of the story, its barrenness and its narrow confines, which lie at the root of this evil.

*Many such portraits of women remained in the possession of the artist, and appeared for the first time at the auction held after his death.

†A sketch for this picture was sold at the auction after his death under the title of *Causerie*. No. 59 of the First Catalogue.

‡A double portrait of Desboutin, which Degas probably used as a study, was sold at the auction after his death. No. 11 of the First Catalogue.

Bouderie. Oil, 1872.

Intérieur. Oil, 1875.

In the case of Degas, we arrive too soon at the end of his fable, and we only retain a jest, a dry phrase, possessing no permanent content: we are unable to seize upon the pictorial import of the story, the universal appeal which is the special province of creative art. The detail in Degas' pictures is, perhaps, not nearly as minute as it is in many pictures of Ingres, and he gives us details in such a way that the manner of their representation only burdens us, instead of setting us free. To Liebermann, whose veneration for Degas made him take to writing, this weakness is a merit. He claims that, in contradistinction to Manet, who is said to portray nothing but a piece of nature seen through his own temperament, Degas produced pictures. We are face to face once more with the time-honoured delusion of the academicians which has led even this enemy of the Academy into its inevitable trap. Admittedly, Degas' work is more final, more finished, than late Manets; but his forms became completed before they gained any appreciable degree of content; his structure acquired an air of completion much as finality is given to a stage setting merely by moving the wings, and such methods are ultimately arbitrary. Manet may have improvised, and he may even have been satisfied with painting but a fraction, as it were, of a composition, only this fraction possessed pictorial entity and formed the pictorial counterpart of a side of his life, whereas Degas made pictures just as a producer makes a stage setting. If the distinction which is drawn by Liebermann really existed, Manet would be nothing but a clever rogue. In his case, the question of mere temperament as opposed to pictorial vision does not arise. One stroke of Manet's brush contains more picture—that is to say, possesses more painted equivalent for what he has seen—than complete pictures by Degas. Degas even composed pictures without expression. It does not improve matters if, apart from this omission, he succeeded in producing an abler composition, because this omission is unpardonable. One might call Manet naturalistic by the side of Cézanne, and one might reproach him with superficial powers of improvisation and lack of synthesis; but by the side of Degas, Manet represents a profounder aspiration and achievement—his whole work possesses pictorial qualities on an incomparably higher level. Liebermann suggests that Degas attached as much importance to the characterisation of his subjects as the German genre-painters, and I agree with him. "They, however—even the best among them, like Waldmüller or Knaus—drew their model as true to character as possible and first superimposed the individual types upon their

picture, which they then coloured, more or less pleasantly, with the result that they often succeeded in producing marvellously true personalities." Of course, Degas hardly descended to such a method. Liebermann points to a composition of Degas, and his task of proving its advantages is not a difficult one. There is no doubt that Degas as a composer of pictures was always far superior, even in his earliest days, to the German genre-painters, but is this necessarily sufficient reason to place the Degas of the *Bouderie*, the *Intérieur*, and of many theatrical and sporting pictures, much higher? Surely, only if he achieved unquestionably more than the Germans did. The fact that he had better means at his disposal, better colours, better methods of composition, is due to the superior tradition to which he was heir, and it would be unjust and mistaken to ascribe merits to him on these grounds; mistaken because the better means, which Degas possessed, fail as soon as his artistic aim is open to question. Indeed, there are cases when the failure of superior methods and means might lead us justifiably to an even severer judgment. Did the young Degas aspire to higher ideals than the family painters of our parents? Did he attain them? Did he really always succeed, especially in his most famous oil paintings, in "transforming literary content into colour and shape," as Liebermann asserts? Is it really true that "the novelistic element has never been overcome so completely by any modern painter" as by Degas? It would be more just to say that no modern painter of importance was so literary in his whole tendency, and what is more to the point, no one has identified himself and his art so unreservedly with this tendency. None of our important men share with him the tragic fate of being admired just because of their failings. People talk of his composition, his colour, his line, and all sorts of other things, and yet they are merely taking to their bosom the same love that leads them to Waldmüller and Knaus. Degas succeeded in deceiving himself and others with his extension beyond the accepted limits of the literary element in painting. For this function he was blessed with a special aptitude, and particularly with unusual tact, qualities which were his own to a much higher degree than his colour and his methods of composition, and which richly deserve a higher measure of praise, but, in comparison with the creative spirit of his great contemporaries, these qualities must remain cheap and ineffectual substitutes. The slender greatness which Degas possessed only developed much later, when the pictures to which Liebermann refers were replaced by a deeper understanding of pictorial qualities, and at

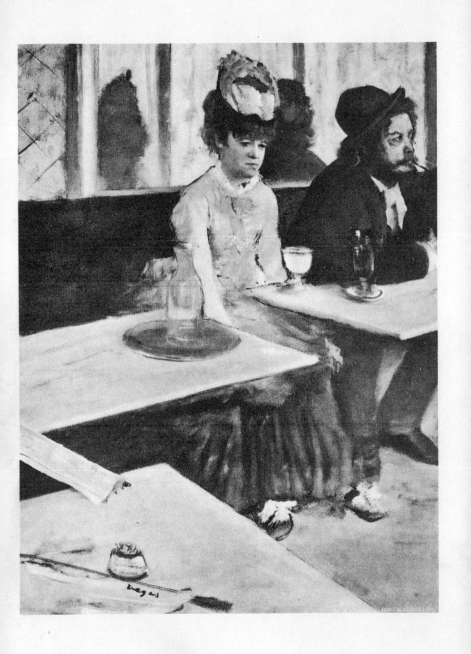

L'Absinthe. Oil, ca. 1876–77.

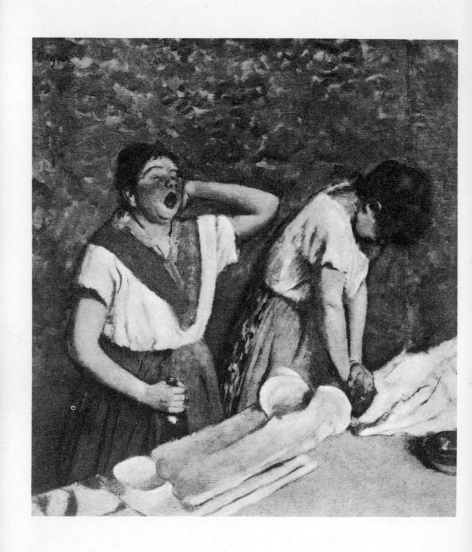

Les Repasseuses. Oil, 1882.

a time when little remained of the brilliant descriptive powers
Liebermann extols.* Degas is one of the most complex artists of the
age—a fact which in itself is almost a criticism. You might write
volumes about Renoir and Cézanne, or Marées. These artists make us
consider the most intricate problems, but their fundamental motives,
their general attitude, is simple and easily recognised. Their instinct
traverses the whole of their history like a red thread, and ultimately
everything they did has continuity. Once the values at which they
aimed are recognised, the rest is a logical development. Degas has
made the consideration of his genesis extraordinarily difficult by the
seclusion of his life. Many of his important pictures are difficult to get
at, their dates are even more uncertain, and the necessary details for
some phases of his career are almost completely lacking. There is no
artist concerning whom we would wish to know more in order to be
able to understand his many moods, and there is no artist of whom we
know less. After his death certain documents came to light in Paris
which may supply a clue to new discoveries, but it is an open question
whether such material is not destined to entangle the threads of the
problem to an even greater extent.

We have discovered Ingres in him. His master disappears. As soon
as we are clear about the doubtful part he played in the progress of
Degas, he disappears in order to return in a different shape, or rather
in many different shapes. Ingres remained for a long time the only
permanent element in Degas' creations. The influence of Manet, to
whom ultimately we owe the Degas we value most, does not seem at
first to have been an entirely progressive factor in his development.
Degas' sensations were not like those of Manet and others. We see him
straying on a side-track, where all Manet stood for has been watered
down into a sterile formula. Degas remained in this stage, with
certain interruptions, for a long period, almost up to the end. He
adopted everything which, in greater or lesser degree, enriched the
most fruitful period of European painting. For the greater part of his
career these acquisitions seemed like ornaments loosely pinned to a
cloak, which covered the academician of the time of Ingres, and even
during the brief period of his maturity, which is somewhat difficult to
determine, Degas only rarely enjoyed the unfettered bliss of the
creator. When it happens we feel that we are in the presence of a
glorious ruin.

*Liebermann's Essay on Degas first appeared in *Kunst und Künstler,* and afterwards
was reissued by Bruno Cassirer, Berlin, in book form. Third Edition, 1902

Manet gave him, above all, the determination to break forever with his anecdotal pictures, and he guided him into the current of his age. The present era thereby gained a new recruit. From 1866 onwards Degas belonged to his own period.

Did he belong to it like the others? Did he fight for it like Manet and Monet and the rest? Was he inflamed by the same enthusiasm? Degas was always separate from his fellows, even when he wanted to go with them. We often feel that he elected to cast in his lot with his age only for lack of a better. His perception was penetrating, and he had the ability to reproduce what he had seen with professional skill, with dignity and wit. He became the exquisite historian of the manners of his age, of its costumes, of certain of its aspects, and he has given us a portion of its real appearance. Since Degas came into this world we see it, a large part of it, through his eyes. He has found formulæ for it which are as much to the purpose as objects of daily use; they resemble certain quick words which we employ in conversation. He himself, however, remained a stranger, like one of the nameless captains of industry who produce our necessities—pots and pans which are too familiar to enter into our imaginative life.

ABOUT this time Degas decided on the sphere to which his art henceforth belonged. It is on the whole the world of sport and of the stage. As early as 1866, his first racing picture appeared in the Salon.* He possibly painted others shortly afterwards, but he certainly made a number of drawings of jockeys and horses. The stately series of sporting pictures which were most instrumental in creating the fame of Degas were painted after the Franco-Prussian War, that is to say, after he returned from New Orleans, about 1873.

Manet painted a few pictures with similar subjects, the earliest of which are dated 1863 and 1865, and they may possibly have influenced Degas.† They delight the artist and the amateur; it is an open question whether they please sportsmen as much as Degas' pictures do. Those by Degas are sporting pictures. This fact characterised them just as it is characteristic of Degas that he chose such special subjects. No other master of the generation of 1870, with the possible exception of the landscape painters, has confined himself to such a limited choice of subjects. The others painted whatever came before

*The picture in the Camondo Collection showing the jockeys riding past bears the date 1862. The observer will not fail to notice beneath this date an older signature. Degas apparently repainted it later on, and then dated it by mistake ten years too early. The picture in its present state was probably painted in 1872. A certain number of early sporting pictures unfortunately only came to light in the auction at his death, among them the large *Cheval emporté* with the fallen jockey (Catalogue No. 56), which is reminiscent of the weaknesses of Courbet.

†The racecourse in the Liebermann Collection is dated 1863, and the picture of the races dated 1865 (Duret Nos. 50, 68, 69), also the two horse-races dated 1872 (Duret 142, 143).

them. They were animated by a pantheism which they wanted to embrace the whole visible world, and they remained faithful to the peculiarities of a visual object only so long as it gave rhythm to their work.

As for Degas, his objects remained what they were; his interest was devoted to the character which Nature, rather than the vision of the artist, had given them. He seized upon the horses, the jockeys, the crowd, the world of the racecourse, with its special colours and lines and its special elegance. He showed how the legs of the jockeys become part of their horses; he revealed the mechanism of the riders intent only on their motion; he depicted the improvised and unpremeditated jostling of the horses at the start, the last minute before the signal is given, what happens before and after the race, and all the things that go on simultaneously in the elegant carriages of the spectators. Curiously enough, he hardly ever painted the actual race in progress. All these things he drew to perfection. There is not a movement which an eye, trained as his was to observe such motion, failed to detect and to seize, and he was able to differentiate between the finest shades in Nature. These pictures contain a collection of fragments of Nature, of details which belong inherently to the subject. For instance, you can see exactly how a horse reacts to this or that pressure of a jockey's leg, exactly how he holds his bit, the stupid, sleepy expression of the animals before they have been roused by the joy of battle, the rapid way in which the attempt of a runaway horse is frustrated, and so on and so forth. The horse of Degas is no longer the steed of the school of Gros, nor yet the companion of Delacroix' heroes with extended nostrils and radiant eyes, who suffer and enjoy the fate of their masters; it is simply an object on four legs bred and trained in a given way, a combination of the relationship of limb to limb from which their efficiency may be calculated. You look at them just as you look at horses before the start in order to back them. I am sure his horses are not merely imaginary horses, but are specially famous animals of the period. To this day a connoisseur might be able to name them. If imagination was instrumental in their creation, it was the imagination of the sportsman, who has arranged in his mind a combination of the qualities in a racehorse which he deems most desirable.

This professionalism, this piercing insight into a special sphere, exercises its effect even upon the layman who has nothing to do with the turf, because this thoroughbred elegance is irresistible. The

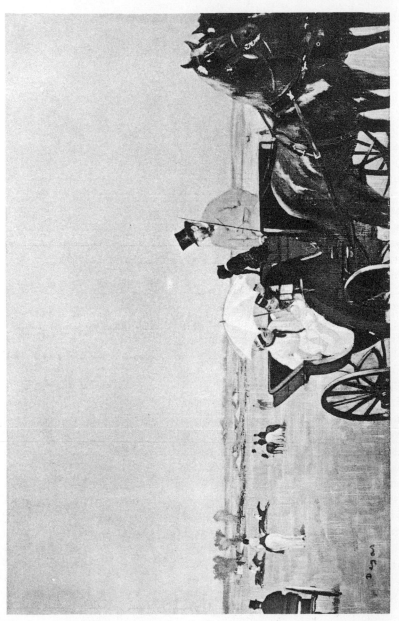

Voiture aux Courses (Aux Courses en Province). Oil, 1873.

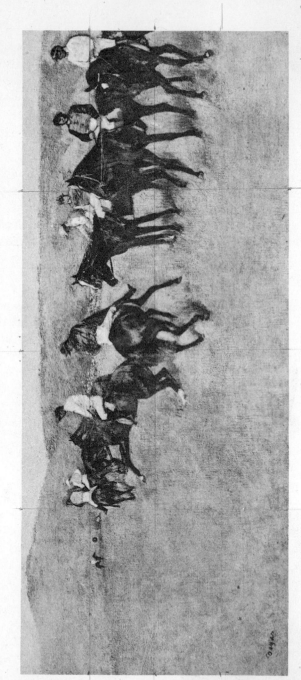

Le Start. Oil, 1878.

inherent nature of racing, with its gaily-coloured jockeys who belong to the world of horses and not to the world of men, exercises a magic over us which is almost calculable on a mathematical basis. There is, indeed, an unaccustomed factor in such concentrated objectivity which is specially charming. We have never beheld such subjects in a more striking form in pictures. Old English engravings portraying the heroes of Epsom give us a similar sensation, but they attract us less, and they do not satisfy so completely our delight in their special peculiarities. Nevertheless, they roughly determine the range of the effect these pictures have on us. The art of Degas gives depth and a certain wealth to this realm without freeing us from its sway.

The result is very great, if we apply as gauge the importance of the subject to the specialist, and if we have the patience to give ourselves up to all its variations. The greatness is minimised if this toleration fails to be granted. In the private collection of Durand-Ruel there are two well-known specimens of this kind, the so-called *Voiture aux Courses* and one of the *Start* pictures. *Voiture aux Courses* was shown in 1874 at the first Impressionist Exhibition to which Degas contributed as an outsider, together with other nonimpressionists, but the picture may have been painted earlier. In those days it bore the title *Aux Courses en Province*. The connoisseur will recognise at once by many clear signs, such as the curious main motif in the foreground—the carriage with the two ladies who seem to have forgotten, in their delight at the baby, the purpose of their Sunday drive—that the picture has nothing to do with Paris. Even the poodle and the coachman are admiring the infant. The joke of the picture is all the more telling because the artist who relates it remains serious— like every good teller of jokes. The draughtsman relates all the facts without in any way emphasising the details which might make us laugh. The observer is inclined to smile less at the humour, than from the pleasure he derives from the peaceable and attractive milieu which is presented with such rare delicacy. Thus the central portion of the picture is, perhaps, the happiest part of the artist's invention, and almost every picture by Degas offers us an opportunity of admiring the fertility of this new method.

As for the rest of the picture, it is an amazing testimony to the craft of illustration. The painter plays a remarkably small part in the picture. The most primitive matière suffices for the expressive details, or rather it covers and conceals them in part. The process of painting seems in this case only to exist in order to frustrate and to blur what

the draughtsman has set upon the canvas. The grey tone is mixed with the local colour without combining them into an organic whole. The background is, as a matter of fact, treated rather more hastily than the foreground. The perspective, which already in this picture is brilliantly handled, shows certain relations of volume convincingly, but only a part of these relations, that is to say, the part which can be measured by a highly-trained eye—relations in which differences in size can be established. He lacks those further suggestions of space which an eye sensitive to colour seeks, and which we demand in any other picture: the quality of coloured spaces and of tones. This lack is felt in all the early pictures of Degas, especially the old paintings for which a rich palette was used. In all cases where the draughtsmanship by itself suffices to satisfy us, this failing becomes less obvious than it is in this picture, or in the smaller painting in the Holzmann Collection, which was probably painted somewhat earlier. The observer is so engaged in contemplating the many harmonious details of the costumes that he forgets to criticise the painter, while he gives way to his delight in this remarkable portrayal of contemporary manners. What there is of landscape in the canvas seems to be a slender heritage from Courbet.

In the *Start,* in the Durand-Ruel Collection, we become aware at once of this lack in Degas. The picture is considerably later and dates from the year 1878. The artist has lost his pleasure in mere description, which impelled him to paint his previous pictures. He is seeking for generalisations and wishes to attain them by the use of less exacting subjects. The necessity for a development based more and more upon purely artistic factors, was always obvious to a man of the intelligence and seriousness of Degas. He always tried to make himself independent of his talent. In this *Start* picture the horses are drawn and distributed admirably, and the jockeys sit there as though they were just additional limbs of their horses. Unfortunately, the observer exhausts his satisfaction in grasping the facts of the picture too quickly, and he longs for further revelations. How could one generalise upon such subjects? Only in the landscape—that is to say, in the space in which the activity presented takes place, but in the picture this space vanishes by the side of the events it contains. It is too obvious that it was not this space which impelled him to present the scene, not this conglomeration of air, or earth, or human beings, but some detail which was given merely arbitrary prominence: the horses with their riders. For the observer who regards the picture, not from

the point of view of a lover of horses, the turf on which the animals move is more important than they are. For this turf must not only be capable of supporting the animals upon it, but it must envisage all the possibilities which such a piece of earth can give rise to. The first glance at the picture suffices to betray the stage wings, and the more vividly the artist has sought to define the living element in his subject, the more irritating and the more aggressive do the lifeless factors—the natural objects—become to the eye. Horses and jockeys cannot exist in an empty space. As soon as this natural point of view gains the upper hand in the observer it is no longer possible to devote as much attention to the fully realised portions of the picture as they merit. Perhaps the jockeys would be less interesting without their gaily-coloured jackets, and in that case the charm of the whole canvas would depend only on its interest as a portrayal of costumes, or else the interest is dependent on the beauty of the horses which are portrayed, which for all their beauty remain painted horses. Even the horses of Alexander do not suffice to make a beautiful picture. All these factors—sport, gaily-coloured jackets, elegant animals—ought to disappear, and yet something of Degas, something which can be recognised simultaneously as coloured jackets and elegant animals, ought to remain. Perhaps we do retain something of Degas' image, of his taste and enjoyment of the racecourse, but whatever we retain is insufficient to make us surrender ourselves without a murmur to the fiction of his picture.

His weaknesses appear in different ways in different pictures, in proportion as one or other of the two traditional factors—design and colour—predominate in such a way as to unbalance the harmony of his painting. Degas hardly ever succeeded in his earlier days in blending these factors perfectly. In his *Défilé* in the Camondo Collection the draughtsman seems to bear the brunt alone. If this were really so, if the picture had really been made only with the draughtsman's pencil, these pictorial qualities might possibly have been justified, but he depends on his colour as upon a strange assistant. There is hardly an attempt to solve his subject pictorially. His horses consist of rough naturalistic outlines which are filled in with colour. The two jockeys in the foreground, with their backs turned to the observer, wear a red and yellow jacket respectively. The red and yellow have been taken from his box of colour, determined by a reality, by a whim, or some other accident, and they remain what they are, immobile, lifeless colours which impede rather than assist

the draughtsmanship of the figures. This lack of coloured accents exercises an even more disturbing effect in the portion of the picture where the crowd is shown on the grand-stand. It seems as though we looked upon shadows, without the bodies which cast them. Not a ray of sun falls upon the many sunshades. The paint is generally thin. Cézanne has covered surfaces with infinitely thinner brushwork and yet created immense depths. In the case of Degas the thinness of the substance implies thinness in every other way. It has the appearance of an awkward first attempt, which he meant to go over later. Many of these pictures are like an egg without a shell. In the *Start* of the Strauss Collection colour and design seem to work hand-in-glove and the weaknesses of Degas immediately recede into the background. The artist appears to have been more reticent; he painted, or so it seems, the whole picture at one sitting and was content with the presentation of his impression. No matter how hasty this canvas may be, this very hastiness has created a value which gives us an impression of completion. In other pictures—for instance, the *Courses* in the Camondo Collection, in which the edge of the canvas cuts into the carriage, or in the horse-races in the Arnhold Collection—we notice the same tendency to create the picture, not out of horses and jockeys, but out of patches, and this intention probably inspired the final version of the *Avant les Courses* in the Camondo Collection. Extraordinarily heavy impasto would appear to be the result of rapid over-paintings, which were made to tone down the gaudiness of the local colour. The background with the chimney-stacks is one of the few landscapes by Degas in which something like atmosphere predominates. There are many cases where we find beginnings of a really pictorial activity, but they disappoint us because they are heterogeneous. Whatever it is that these pictures lack would be less evident if Degas himself were not so identified with what we miss. A virtuoso whose honesty had fewer scruples would have attempted to fill out these empty spaces.

In criticising Degas, we are of course influenced by new achievements which the history of Art has revealed to us, achievements which are, perhaps, more akin to the spirit of our day than the activity of Degas at the time of which we speak. Great contemporaries have opened our eyes to his failings. It is amazing to observe in the rich rooms of the Camondo Collection in the Louvre how indifferent we are, especially before his most famous pictures, which were admired by a minority which has usually chosen with such certainty. As long

Avant les Courses. Oil, ca. 1878.

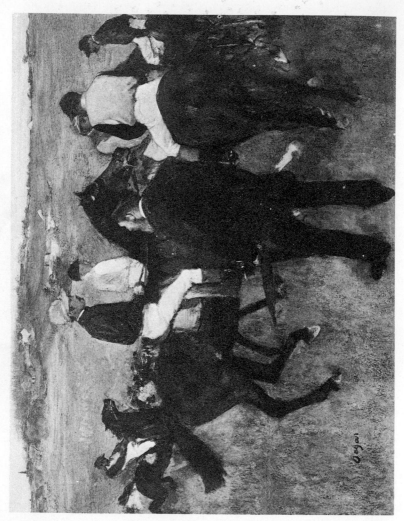

Chevaux de Courses. Oil, ca. 1872.

as they were hanging alone in one room in the house of Camondo they presented a solid front, and any criticism against this picture or the other became merely trivial, but now that they hang among Corots, Jongkinds and Cézannes, and near Manets, they are defenceless, and even those among them which resist criticism suffer from our scepticism.

A water-colour by Cézanne on which only a few watery strokes can be seen attracts us far more, and when looking at the *Fifre* it is impossible to conceive how people could ever talk of Manet and Degas on a par. The very artists to whose circle Degas belonged have fulfilled the demand under which he broke down. This demand is considered peculiarly modern, because it was made chiefly by the landscape artists of that period, who regarded the atmosphere as the essential substance of their pictures. The fundamental validity of this demand remains quite untouched by any question of actuality, because it is concerned with nothing more nor less than the organisation which penetrates into every portion of the picture. Whether this organic structure is called light or atmosphere or style is not to the point. For this reason, it would be a gross error to ascribe the difference between Degas and his contemporaries to any refusal on his part to yield to modernism, and to conclude that the qualities Degas lacked were in some way a proof of his claim to be ranked with the old masters. The reverse is true. In none of the old masters do we miss this same organisation, not even the Primitives, who knew nothing about our theories of atmosphere—not even the Primitives for whom sunshine either existed not at all or only in the shape of a more or less arbitrary source of light. The old masters organised their pictures in their way, and our masters have fulfilled the valid ideals of their forerunners with the means proper to their age. Manet's *Contemporanéité* is a catchword like a hundred others. It serves its purpose at the moment in which it is used; it is a palette, a technique, but it does not decide the comparison in his favour. It would be truer to say that the victory goes to Manet because there is something of the old master in him, while Degas possesses a novelty which grows old and of which the world grows weary. In the Durand-Ruel Collection there is a tiny sketch for a horserace by Manet. This sketch gives us none of the suggestive detail we find in Degas, but it does give us the essential impression which we carry away with us after a day at the races: the glowing radiance of an intensified human activity. The generalisation is perfect in spite of the triviality of the little picture. The rapid

strokes placed there at one sitting create an irresistible symbol of motion. It reacts upon us in quite a different way from the detailed description of an ever-changing condition. It supplies us, our sensibilities, with motion—the horses become the jockeys that give whip and spur to our sensations.

This difference, not between the completed picture and the sketch, but between two different points of view, distinguishes all Degas' work of this period from all the pictures by Manet. The finished works by Manet in which details play a part accentuate this difference to an overwhelming degree. By the side of the racing picture in the Whittemore Collection every similar kind of picture by Degas is only like helpless stammering. Even a comparison with the tiny sketch belonging to Durand-Ruel, or with the no larger pearl-like water-colour of a similar subject in the collection of Denys Cochin, in fact, even Manet's well-known lithograph of *The Races* leads us to the same conclusion. Manet creates living organisms by all and every means. He brings to every one of his subjects, which in his early work are more objective than they are later on, a motion penetrating everything which lends to his work a sense of direction and unity. Sensibility and form seem in his case to be synonymous terms. In Degas' racing pictures the form consists of the legs of horses and jackets of jockeys. In his earlier pictures of a different genre other objects take the place of the horses and the jockeys, but the artistic attitude remains the same. At the Vente Henri Rouart, which developed into the triumph of the master of the *Danseuses à la Barre,* there was a *Plage* by Manet and one by Degas. The manner of the one was clearly influenced by that of the other, and no one who thought for a moment, and who had eyes in his head, could fail to notice the almost painful difference between the two: the emptiness in the Degas, the accidental nature of his groups which always remain accidents, the almost feminine weakness of his design, the bodiless colour; whereas in the Manet no single object, but existence seemed to be concentrated. The comparison would have been still more convincing if, instead of the *Plage* by Manet, the exhibition had contained a subject bearing a still closer resemblance, for instance, the little picture *Boulogne-sur-Mer* of 1869, which Degas must have known,* with all its tiny doll-like figures moving like human beings and at one with the shore and the sea—a small nation set in Nature. In

Vide my book on Manet, No. 76.

the picture by Degas the dolls resemble human beings closely.

He was considered one of the wittiest Parisians, and he belonged to the people who regarded the Boulevard as a kind of forum of *esprit,* where phrases were forged which afterwards penetrated into every street, and which were not so clumsy as the omnibuses which have subsequently suppressed them. There is many a winged phrase coined by him, and there are people who collect them like pictures.* These phrases are witty, but they seem like the revenge of a speaker to whom speech is difficult. On this point those contemporaries, who at any time saw much of him—no one could stand it for long—all agree. He was really less brilliant than easily piqued. In the early days of his youth there was still salons in Paris which he visited, such as Charpentier's and the Goncourts'. He was capable of sitting there for the whole evening without opening his mouth. His brilliant *bon mots* were the product of a special mood which was tinged with bitterness and which he carried about with him. His hobby-horse was to rail at successful exhibitors who had obtained a distinction in the Salon by some mistake—among whom he counted himself. Even such intimate friends as the de Nittis were not spared on such occasions.† He never could pardon Manet's popularity, and the darts he shot at him became more and more bitter as time went on.‡ His wit was seldom spontaneous, and seemed to be at his disposal only on special occasions. His contemporaries regarded him as one of the ablest people, but when you sought to inquire further they forgot about whom you were speaking, and turned to the discussion of Manet. When you mentioned Manet's name a smile played about their lips as if they could still see him before their eyes. Here was a man who had *esprit* for every situation, who found the right word for everybody, and whose wit was the result of improvisation. The wit of Degas had an air of premeditation. Manet's jokes, which were not lacking in spice, flowed from him, they were less pointed and more difficult to remember. Somehow there was more of himself in what Manet said than of the people or the things of which he spoke. At the same time,

*A certain number are to be found in the *Notes sur la Peinture Moderne,* by the painter J. E. Blanche (*Revue de Paris* of the 1st and 15th January, 1913), and also in Lafond. Lafond also published a number of Sonnets by Degas. It is said that the painter wrote a great deal of poetry in his youth. The few specimens which Lafond has printed represent little more than the efforts of an amateur of taste.

†Compare for instance the *Notes et Souvenirs du peintre Joseph de Nittis, Librairies Réunies,* Paris, 1895, which were collected by the wife of the painter.

‡Compare the chapter on Degas in the last edition of my *History of Modern Art.*

the ironic Degas, who was feared everywhere, had at bottom a kindly soul, and all his quarrels with other people, which have since become legendary in Paris, were the result of the demands he made upon his surroundings, which he himself at any rate fulfilled completely. Even in his friendship there was a hidden romanticism. At heart he did not belong to Paris, although he knew it better than anyone else, nor did he belong to his age, although it contained all the roots of his art.

The blame for the breach in the friendship between Manet and Degas must be laid at Manet's door. Degas had painted a double portrait: Manet sitting on a sofa and listening to his wife playing the piano. Manet thought the picture of his wife unlike her, and he cut the canvas so that her face was missing.* When Degas heard this he demanded his picture back and the breach was complete. Later on their quarrel became more poignant. Degas told everyone who cared to listen that Manet had stolen his subjects, an assertion which fell to the ground on the least investigation, and was the reverse of the truth. He also accused him of having stolen from Claude Monet. Julius Elias is mistaken in attempting to justify Degas on this point.† No serious person will ever dream of honouring Manet as the inventor of the *plein air* doctrine. Manet, like all the rest of his circle, purified his palette and lightened it under the influence of Monet; how much benefit his painting derived from this process is another question, but Claude Monet tried at a much earlier period to adopt the subjects and the method of painting of Manet—in his early seascapes, for instance. Manet's words on first seeing Monet's pictures are well known.

The antipathy of Degas for successful painters remained constant to the end. From the middle of the 'eighties onwards he ceased to exhibit. He avoided, sometimes gruffly, every attempt at public recognition. Anything which looked even remotely like publicity was loathsome to him. When his own portrait painted by Blanche appeared in the *Studio*, Degas, who had been on intimate terms with the family for a generation, sent a commissionaire to the house of Blanche to return to him the pictures which he had given to Degas, and to demand the return of those which Degas had given to him.

*The picture appeared in this condition at the auction after Degas' death. It was reproduced in the First Catalogue as No. 2.

†*Vide* the Essay on Degas in the *Neue Rundschau*, September, 1917. Also the paragraph in the text of the *Skizzenmappe* (Marées Society).

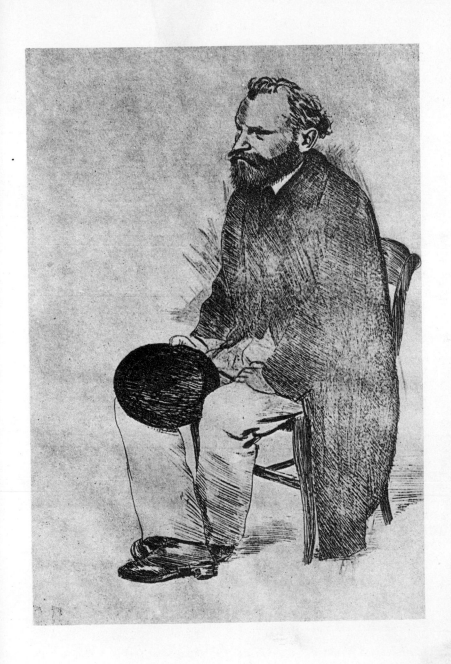

Portrait of Manet. Etching, ca. 1866.

Aux Ambassadeurs. Oil, ca. 1875.

Degas did not paint his sporting pictures in the open. He made drawings of horses and figures, noted the colours, and invented the landscape to suit them. Many a master of glorious pictures employed similar methods. Every method is a good one, even the most primitive. Courbet has given us pictures that seem to us as if they were sucked from nature and yet they were painted from memory. Delacroix invariably adopted similar tactics, and used some silly engraving which he happened to have in front of him. A painter in Paris whom I know used the pattern of the veins in the marble of his chimney-piece as the basis for a composition of Amazons in battle.

Such methods succeed if the artist can retain in his mind the most essential factors, and if some slight assistance to memory suffices to set in motion his innate rhythm. All methods can only serve to increase the playful impulse in an artist, and nature can only serve to widen his horizon and to give him profundity.

It would be mistaken to assume that the landscapes of the sporting pictures were a failure. The same landscapes might have served the purpose for other horses and other jockeys. It would be still more mistaken to suppose that the unsuccessful details in the pictures do not spoil all the rest. It is just the rest which concerns us. You cannot bargain with art. Trivial details are like words which we let slip carelessly, but such words can easily be retrieved and completed by a phrase. These methods of escape fail in the case of serious statements, or in the case of organic elements in a picture. In the science of medicine there may be specialists, nose specialists, throat specialists, who claim to understand and to control the whole of the human body

by their knowledge of one single organ. The intelligence of the average man will look upon such claims with a doubtful eye, but in art specialisation implies the exercise of faculties upon the wrong object. The generation to which Degas belonged had recognised this fact. They wanted not a part but the whole, hence their disinclination towards everything which, even from a distance, looked like a ready-made subject. Hence, too, their love of landscape. Later on, even this developed into a new form of specialisation, as did the love of the forest which inspired the older generation of Fontainebleau. Originally, their longing for the open air was the symbol of their desire for liberation, a longing for universality, and for this reason all contemporary masters were landscape painters at one time or another, and even the mistakes of their school showed traces of this origin.

Even in this connection Degas was an exception. He tried his powers in every conceivable sphere, but he was never a landscape painter. The series of small pastel landscapes, one of which seems reminiscent of a scene in Southern Italy, in the collection of Beurdelay in Paris (another one entitled *Le Vésuve* was at the auction after the artist's death)* betrays amazingly dull qualities. At the first auction two early landscapes in oils appeared, forest scenes, both unfinished, faintly reminiscent of Courbet, and extremely feeble.† The still-lifes of Degas are equally rare. His classicism, which really precluded the choice of natural subjects, made him unable to see them.

Degas did not hide the weakness of his sporting pictures from himself. He considered his landscape responsible for the weakness, and he sought to overcome the obstacle by arbitrary means. As time went on he gave increasing preference to subjects which he could see and paint within four walls. While his contemporaries swarmed to the borders of the Seine, Degas retreated to his studio and made his models pose for him before a solid wall, which he could choose at will. His models did not have an easy time of it. He treated their arms and legs as if they belonged, not to human beings, but to puppets. He twisted their heads as far as mortal muscles would extend. He forced them to crouch down to the ground, and he made them stand still in

*Reproduced in the catalogue of the second auction as No. 199.
†Reproduced in the catalogue of the first auction as Nos. 40–41. At the second auction there was a subject in the style of Corot, *St. Valéry-sur-Somme*, also rather insignificant. (Catalogue of the second auction, No. 44.)

quite arbitrary poses which were in reality arrested movements between two normal postures. He was merciless, more merciless even than Courbet, the "faiseur de chair." Anyone who had sat a couple of hours to Degas could feel every bone in his body. He placed girls in front of walls and dressing-tables, in front of the rounded shape of a bath-tub, in front of mirrors, or he let them stretch themselves naked in a bath-tub, holding a large sponge in their extended fingers. Others he placed at the edge of the stage of the Café Chantant in the Champs Elysées, and the footlights and spot-lights fell glaringly upon their made-up cheeks; others he put before the jagged wings of the stage, or else he made them stand with one leg raised to the taut rope in the practice-room, whilst others contorted their bodies in the background. He always gave preference to postures which suggested movement, but he never did what Cézanne used to do, namely, place his figures simply in front of space, thereby giving them life and motion simultaneously. Degas was fond of drawing two or three dancers at once and making parallelograms out of arms and legs which pointed in the same direction. He always chose peculiar situations and brought his peculiar vision to bear upon them. By this means he evaded natural difficulties and created artificial ones.

Degas did not give up his sporting pictures and other open-air subjects altogether—such subjects are rare in his work—and some of them might equally well have been painted in his studio, for instance the three beautifully drawn girls combing their hair, in the collection of Henry Lerolle. These pictures continued for a while to be painted at the same time as his interiors, and a number even of these date back to his early period. The difference in quality between these two types cannot be determined without further consideration, but it becomes evident when we add the sum of achievement of each type and then compare the result. In the beginning the interiors gained rather by the subjects, which helped to hide his weaknesses, than by their greater artistic merits, but even so, there are many exceptions. We find them where we should least expect them, a long way from the famous pictures whose intellectual and capricious peculiarities please the Degas connoisseur. Two of these, which were painted probably before 1870, hung, or used to hang, in the Viau* collection. In both portraits the same girl appears to be represented—in one case only the head, and in the other the whole figure, seated on a red chair and dressed in a

*The collection was sold during the War. In the studio of Degas there were several portraits similar in quality. They are reproduced in the catalogue of the Degas sale.

red robe. Degas has never painted anything less pretentious, and only rarely has this modern artist, whom we like to think of as the representative of the most exclusive Parisians, been more old-fashioned. It is difficult to believe that these pictures, especially the one of the head only, belong to the generation of Manet. It would be easier to suppose that they are contemporaneous with the works of Corot. The first reaction given by these paintings will probably not allow us to analyse the artistic impression they create on us. The question, which we ask ourselves before all others about so many pictures by him—how did he do that?—is silenced. We are carried away by the quiet life in these simple forms. His *matière* is comparable to the modest content of the pictures. The thinnest of impastos barely covers the grain of the canvas. The flesh is coloured, as if by a breath, with a warm, rosy brown which seems to emanate from the girl's hair, and just a touch of red on her lips and cheeks. Is it drawing? Is it painting? There is something in this face of Ingres, who was a great draughtsman, and something of the girl by Vermeer, who was a great painter. The whole thing is a very gentle vision, soft as a breath and unintentional.

This delicate and unpretentious charm, for which a small canvas seems to be appropriate, becomes disproportionately enlarged in the big Neapolitan family group which was discussed above. Degas' ability to create forms fails before the infinitely more difficult problem, and all that he gives us are certain values which we call taste. The *Femme à la Potiche*, 1872, which is now in the Louvre, reminds us of the early manner of the girl's head. Degas attempted to add to this almost anonymous simplicity by the richer means of Manet's colouring, and he thereby produced one of his best oil-paintings. His simplicity became subjective strength. His flesh is painted with a delicious mixture of greenish and bluish grey-white and pink—all of them colours which, in concentrated form, appear in the blue Delft vase with the red cactus blossoms and the heavy green leaves. The simple grey dress with the touch of orange in Degas' picture harmonises admirably, and the juicy green leaves warm the subdued background. The good taste of the man who knows how to arrange the table, the setting of his room, struggles with the painter in him for mastery, but he does not suppress the essential self-glory of the pictorial element in the canvas. On the blue table-cloth with the red dots lies a pair of yellow gloves which the Manet who painted the *Balcon* might have forgotten. About this time, probably still in the year 1872, Degas produced three pictures which signalise his entry

Ballet de Robert le Diable. Oil, 1872.

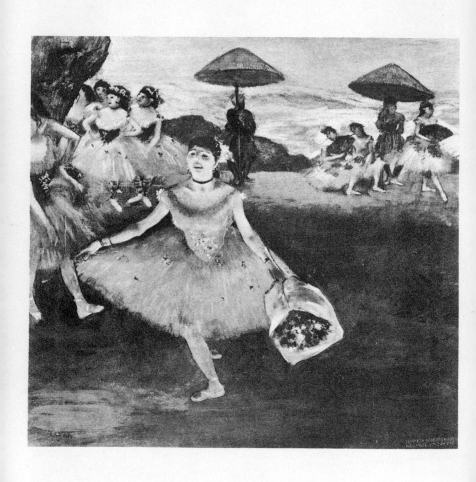

La Danseuse au Bouquet. Pastel, ca. 1877.

into a new world of subjects.* He painted his first theatre pictures, *Musiciens à l'Orchestre,* now in the Städel Institute, the stage with its dancers, in front of them three heads of musicians with their backs turned to the spectator; then a similar picture in which the musicians are partially turned in profile towards the right. This he gave to one of the musicians he depicted, and it is now, together with a number of early works, in the possession of the sister of the musician, Mademoiselle Dihau.† Finally, the ballet *Robert le Diable,* which is now in the Victoria and Albert Museum. All these pictures present the same problem: the semi-darkness of the auditorium and the bright stage, and in all three of them the artist fails to solve the most important part of it. The auditorium and the stage fall apart like two distinct worlds, and this cleavage is not only due to the difference of the lighting. The method of treatment of the lower portions of the three pictures is so contradictory to the treatment of the upper portions, that is to say the stage, that it would not be unreasonable to suspect the work of two different artists in this picture. The auditorium and the orchestra are presented with the most painstaking exactitude, the heads are detailed portraits, the colour taken from a traditionally dirty palette serves only to provide an illusion of reality. In the upper half we see the glaring stage, not coloured but crassly gaudy. The figures depicted on it were viewed from a totally different distance from the heads of the musicians, and they seem as unreal as the people in the orchestra appear tangible. The action upon the stage appears to take place not only outside the orchestra, but outside the whole picture. The stage in this case has become an artificial "prop" in a two-fold sense, it is fundamentally the same as the landscape in the sporting pictures, that is to say an arbitrary background.

How far are these efforts below Degas' mature creations of similar subjects, in which it is just his colour which has changed the theatre into a fairy world! It is a long journey from here to the *Danseuse au Bouquet,* which he painted only a few years later, and which is now in the Camondo Collection. When Degas was near his forties he seems to have made a fresh start much in the way that he always started. Every new picture seemed to throw him back instead of assisting his progress, although he was confident that his new subject would lead

*At any rate, the first which show his style. His first theatre picture, *Mademoiselle Fiocre dans le Ballet de "La Source,"* was painted in the 'sixties in the manner of the genre painters. It came to light at the auction after his death. See Catalogue 1, No. 8.

†These pictures, which represent the whole of her collection, are left in her will, so the owner informs me, to the Louvre.

him to the discovery of the right means. It was at this period that he drank the cup of bitterness to the dregs.

The manner of these three theatre pictures, which surprise the Parisian friends of Degas, is quite familiar to those who have studied German art of the nineteenth century. This peculiar faithfulness of the portraitist, who clings to a face as it were to a religious faith and who forgets everything else in the process, is a too familiar ghost in many German works. It is characteristic particularly of one German whose work does not spring to the mind at all when we contemplate Degas, but who none the less had much kinship with him: Menzel. He possesses the same realism which compels the painter to stand as close as possible to his model, which often inveigles him into the trap of painting over life-size. There is the same professionalism in all the details, which fails completely before the problem as a whole, the same play with artifical light effects, which lack all luminosity, and the same insensibility to the charms of colour and of tone. I refer to the Menzel of the later period who was not unknown in Paris, and I am able to mention here what an intimate friend of Degas (who took the precaution of requesting me to withhold his name) has told me, namely, that Degas himself owned to being influenced considerably by the works of Menzel. He never missed an opportunity of going to see pictures by this German painter when they could be seen at the galleries of Goupil and other dealers, and he did not hesitate to confess his admiration.* I do not know whether Degas was personally acquainted with Menzel. It is by no means impossible, as Menzel, who was in Paris in 1867-8, met a great number of French painters.

Once we recognise the existence of this relationship, we find its traces in many other pictures by Degas, and the extraordinary parallelism between two men whose work and tradition are at such variance must fill us with surprise. The same subject in many pictures by Menzel and Manet does not indicate the shadow of an approach. The garden of the Tuileries painted by the German, and that painted by the Frenchman, a scene in which, perhaps, the same people appear, might have been painted at opposite ends of the earth, and the common element between Menzel and Degas is in no way destroyed by the difference of their subjects. We could imagine that Menzel

*Degas spoke to Elias in enthusiastic terms shortly before the late War about the Menzel Exhibition of 1885 in the Tuileries, although he lavished equal enthusiasm on Cornelius, whom he counted among the greatest draughtsmen. See the essay previously referred to in the *Neue Rundschau*.

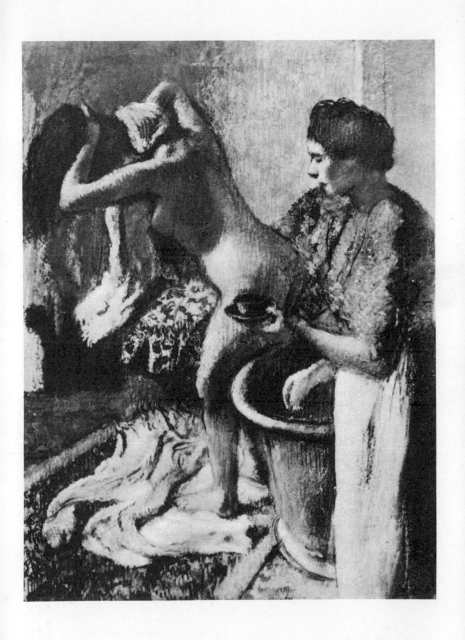

La Toilette. Pastel, ca. 1890.

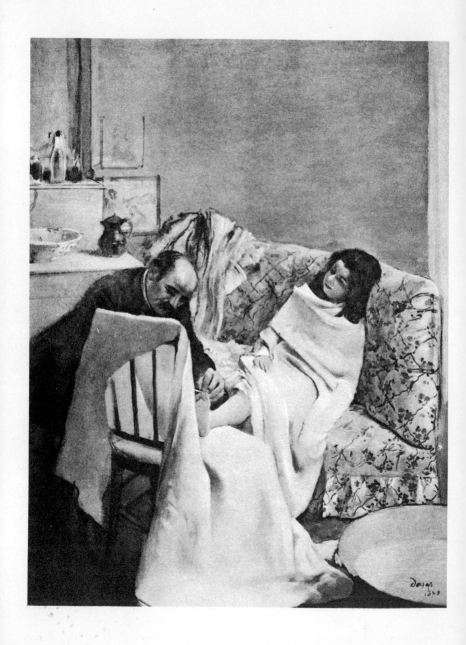

Le Pédicure. Oil, ca. 1873.

might have painted racing pictures somewhat in the style of Degas. The details would have been different, also the degree of good taste, which is another detail, but their fundamental attitude to the problem, that is to say the joy of the draughtsman, and the mechanism of limbs would be the same. The landscape with the chimney-stacks in the *Défilé* of the Camondo Collection has the traits of an early Menzel, and the fact that we regard it more seriously than the artificial scenery of the sporting pictures is due to this relationship, though Degas, as long as he used a brush, never possessed the fire of Menzel who once was young, and he never attained to Menzel's early mastery. The Germans may for once permit themselves the satisfaction of noting the superiority of one of their compatriots to a Frenchman of a similar tendency, a superiority moreover, based on factors which, as a rule, operate against German painters. Menzel, the painter, especially in the first forty years of his career, is incomparably more convincing than Degas. He is always, as it were, a fragmentary artist, his professional antecedents are never completely overcome, his work is brittle and confined to a small range of sensuous charms, and he never rises above mere virtuosity; a man with human things to say who says them convincingly in his own manner. It is just this groping manner in the youthful Menzel, obeying the gentle rhythm of an unconscious lyricism, which to some degree, commands our sympathetic interest. He was a born artist; Degas, even in his most seductive garb, rarely succeeded in hiding the academician who was innate in him. Both men were draughtsmen. Degas drew consciously, while Menzel originally did so unconsciously, and the tragedy of Menzel is to be found in the fact that gradually he became conscious of it. In the beginning, Degas shared the aims of the Classicists, aims that have always proved transient. Draughtsmanship was really nothing but a part of essential memory for objects, which he ought to have known by heart, so that one day they might appear in the shape of rhythms that have never been seen before, no matter whether they came to life as drawings or paintings. The art of Menzel could never be completely destroyed by his passion, his mania almost, for taking notes, which existed before his draughtsmanship, and was the capacity to absorb the whole world and to create a new one. We call this capacity, in contradistinction to the reproductive type of drawing, the pictorial quality, and we mean by it a higher degree of presentation; we call it modern because it is akin to the life we know. Degas in his later period—he attempted always to find a means of

participating in life—finally found a narrow path for himself. When he did so there really remained nothing for him to conquer.

Degas was favoured by better friends and companions, whereas Menzel had the good fortune to meet at the right moment—when by his own activity he had acquired a certain creative ability—Constable, who supplied his most fundamental needs. Degas became a painter more at the bidding of his own culture than from an inner call, and he thus gravitated towards Ingres. It would have been more natural to have predicted Menzel's fate for the Frenchman than to suppose that the blind zeal of the German would lead him to mere virtuosity. The *Théâtre Gymnase* represents a level to which Degas never attained. This theatre in which the rhythm of the colours alone suffices to make the play—a play which embraces simultaneously the orchestra, the stage and the auditorium—Degas, the painter, never beheld. The Frenchman has, of course, a best period of his own. The atmosphere of the two girl portraits in the Viau Collection is comparable to the milieu of certain interiors by Menzel, painted in the forties of Menzel's life, but somehow we feel the restraint of the Classicists in Degas. Manet belonged to a superior, or shall we say, a more humanistic tradition. His greater freedom makes the surprising intimacy of his scenes possible, thereby creating higher values. The Frenchman approaches the German closely in his sketchy portrait of Rouart and his daughters, or in his *Dame au Miroir* in the Doucet Collection, which is one of the best Degas of the seventies, generous in treatment and rich in colour, in spite of its brown palette.* We feel in this picture the same spontaneous freedom, which delights us most in Menzel when he succeeded in producing it quite unconsciously. The little Degas sold at the Vente H. Rouart, the three dancers at the window through which you see the houses opposite, recalls the beautiful simplicity and clarity of Menzel at his best. It reminds us of *Des Künstlers Zimmer in der Ritterstrasse* in the National Gallery in Berlin. Many an admirer of the art of Degas values this little picture more highly than the important canvases which were sold at the famous Degas sale. On the other hand, as soon as we confine ourselves to Menzel's special sphere, his pencil drawings, the relationship between him and Degas disappears, even if we leave out of account the

*This picture must not be mistaken for another one called *La Toilette*, in the possession of Vollard, which is an unfinished picture of an earlier period in which the greater richness of palette leads to a certain suggestive dimness. A pastel which was sold at the Degas sale, Catalogue 2, No. 124, has reference to this picture.

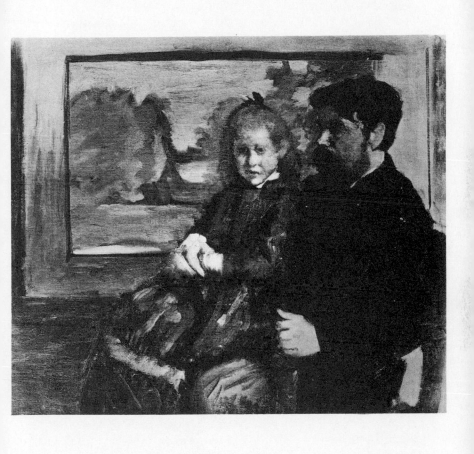

Portrait of Henri Rouart and His Daughter. Oil, ca. 1875.

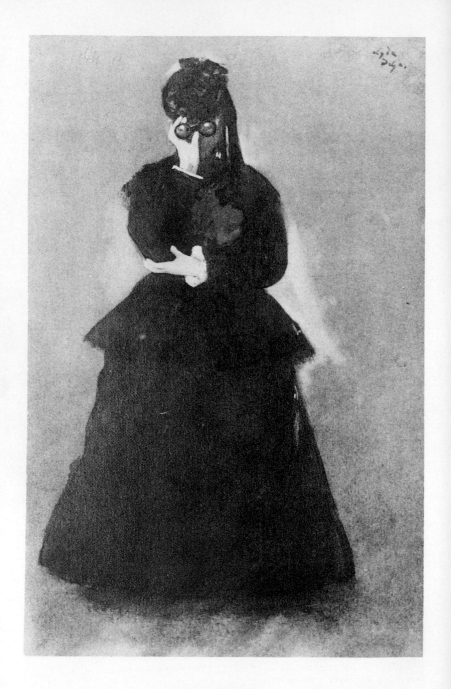

Lyda. Oil, 1877.

very early Ingres-like drawings. Nevertheless, even here there are certain vague points of contact. For instance, the pencil drawings which Degas used as studies for his picture of his friend Manet, which resemble so little the image which we have of Manet himself. These drawings are reminiscent of the later Menzel, in so far as drawings which lack all virtuosity can be, and they look rather like the efforts of an amateur who is a kind of spiritual relation of Menzel.* Certain traits of Menzel continue even after 1875, for instance, in the picture called *Lyda*, the lady with the opera glasses. The truly Degasian invention of hiding the face with the gloved hand holding a pair of opera-glasses, is a subject which would have delighted Menzel. Menzel and Degas were closely related in the manner in which they regarded the subject, the delight they took in complicating visual objects. *Miss Lola au Cirque Fernando*, the lady in tights who is being hoisted to the ceiling of the circus by the ropes she holds with her teeth, depicted with as much detail of the costume and the surrounding architecture as if the painter had been hoisted to the roof with her himself, is nothing but Menzelian virtuosity. The picture was painted in 1879.† Soon after this period the art of Degas took a turn which raised him far above his strange Teutonic relation.

In Paris the name of Menzel, because his early work is unknown, means, very unjustly, Meissonier. For a long time Degas might easily have become the heir to this miniaturist of soldiers. A certain portion of his success, which was far in advance of his greater contemporaries, is explained by the mistake made by the bourgeois, who regarded his dancers as the legitimate sisters of the soldiers of their idolised Meissonier. Fifty years ago, before Degas enjoyed this popularity, we could have understood such an error. At that time he painted several

*We except the one which is not in pencil but in ink, showing the whole figure of Manet—this is probably the most extraordinary drawing in existence of Manet; in it we can almost imagine that we see the beginnings of his illness. The suffering features almost disappear beneath the loose texture of the ink. The three pencil drawings (they and the water-colour have for some years been in the collection of Ernest Rouart, and one of the drawings is reproduced by Lafond) remind us of the early portrait of Manet by Braquemond. The pen drawing is probably a little later. It is an open question whether these drawings have any connection with the totally different etched portraits of Manet by Degas, which are almost like caricatures. There is a complete collection of these strangely unsuccessful etchings in the Doucet library. No. 210, Catalogue 2, of the Vente Degas revealed a sheet with three drawings of Manet, which belonged to the same series. They are as expressionless as the others; the picture mentioned above, Manet's portrait in oils, would appear to be better.

†This picture is in the American collection of Cawther Mulock. A sketch in pastels for this picture (dated January, 1879) was sold at the Vente Degas, Catalogue I, No. 251.

pictures which a hasty critic might have ascribed to the influence of Meissonier. Such a critic would, of course, have been crude in his judgment, incapable of appreciating nice shades, such as the difference between the weakest of the interiors by Vermeer of Delft and the best genre pictures of Peter de Hoogh.

Degas was for a time a minor master who succeeded in creating a certain charm on a minute scale, derived from a limited sphere. He possessed certain legible, and shall we say, appetising qualities, which did not presuppose much effort on the part of the observer, and he possessed also an element of surprise which had the additional charm of a game of hide-and-seek. But even the severest critic must own that Degas possessed something over and above this. His minor art always contained a certain rarity, to which Meissonier never attained. Of course, we might never have suspected this rare quality in the work of this period were we not familiar with the work of his maturity. We do not know, however, whether the charm of this quality will not disappear in the course of time. The most attractive picture which is representative of Degas' minor art is probably the *Pédicure,* dated 1873, which is hung in the Louvre in the Camondo Collection. The picture shows us a wise old man toiling at the feet of a beautiful girl in a white bathgown, who occupies her time in well-earned slumber on a pink sofa. The damp fumes of a warm bath still cling to her body, her dark hair casts a pinkish-grey shadow over her, and the details are brilliantly portrayed in all their gaiety. The drawing, exact in every line, is made from a point slightly above the model, but the exactitude of this picture is not over-emphasised. The colour, although adding to the precision of the objects portrayed, is playful and well-organised, and it justifies a rich palette by the use of a rich variety of tones. The portrait is only a bibelot, and the sensibility which created it does not extend much beyond the charm that the scene has in itself, but the artist has rarely fashioned a more fascinating toy of his moods. Suddenly, Degas appears as such a master of colour that it is hard to conceive why this capacity has not always been apparent. This canvas reveals a degree of taste which, though it paled in his earlier works by the side of a mere Menzel, has been elevated here to the level of creative instinct. While we enjoy the taste revealed in the picture we suddenly notice something like life in the sleeping figure of the girl, and thus the bibelot almost becomes a work of art.

\mathbf{A}PART from the object portrayed, what is it that lends effect to the pictures we have so far discussed? If we exclude the question of colour, which really did not play its part to the full before the last period, we are faced by two artistic factors which are emphasised in proportion as our examination proceeds: space-effect and field of vision. Both these factors, especially the former, differentiate the artist from all his contemporaries. They negate his relationship to Menzel, raise his pictures above genre painting and ennoble their naturalism.

The problem of space, that is the effect of depth, is, of course, part of every realistic programme which is logical in its naturalistic tendency. For how else could we believe in the fiction of paint? Impressionists suspected it as a symbol of academic methods, as a cheap means to achieve illusion, which forgot artistic aims in its desire to produce probability. They regarded it as an obstacle to the solution of the problems of colour and of tone. We know how violently Manet was opposed to all objective forms of modelling. In this respect, Degas followed in Manet's footsteps less than anyone else. Degas not only refused to sacrifice anything in his method of presenting space, but he even exaggerated it, and in spite of it, we never find in Degas anything like the dubious optical illusions in certain Velasquez', or in products of other able but more modern hands. In fact, this exaggeration served, no matter how paradoxical it may sound, to limit his realism, and to present the mental quality of the objects he portrayed. One might almost imagine that Degas attempted to find a stylistic aid in this method, but the paradox

disappears as soon as we visualise the other means which aid methods of presenting three-dimensional space.

In 1873, Degas visited his relations in New Orleans. It is said that he was impelled to go there because he was dissatisfied with the political situation in France. He took part in the Franco-Prussian War, and we are told that he strove fanatically to prevent the surrender of Paris, and that he viewed the change from monarchy to republic with undisguised disapproval. His stay in New Orleans lasted several months, and its most important fruit was *Le Bureau de Coton, New Orleans*, which is to-day the pride of the museum in Pau. The picture reveals the surroundings in which his relatives lived, which were new to the Parisian: the patriarchal office of a merchant. The old gentleman, who is seated in the foreground, top hat glued to his head, fingering a sample of cloth at his leisure, is the uncle of the painter, the owner of the factory. He is a kind of Père Bertin from the other side of the water. He represents, not a whole epoch, like the famous bourgeois of Ingres, but he represents just as perfectly the less significant but more specific atmosphere of this merchant of a bygone generation. The picture contains besides the office boys, the clerks, the customers, everything that belongs to a factory, even the peculiar and rather dry air of such places. For these varieties of types, and for this impersonal expression of commercial intercourse, the interest of which depends only upon its detail, Ingres lacked the necessary qualifications. The pupil seemed made for such a task. His sobriety exceeded the barrenness of these surroundings and turned them into a mechanism which in reality is cloaked with sentiment. The colour of this picture is kept within modest confines, and consists in the main only of the natural contrasts between the black of the men's clothes and the white of the goods, papers, etc. The greyish walls help to bind together the extremes of black and white. The simplicity which Degas found here must have been of material assistance to him. The pictorial element was dependent upon draughtsmanship. He attained success by heightening the powers of which he was master, whose use he had failed to understand in his earlier work. He presented these colourless people and their surroundings with the same acute vision which he brought to bear on the peculiar postures of his racehorses and jockeys, but in this case he succeeded in organising his creatures perfectly within his ideated space. There is hardly a picture, since the days of the old masters, in which the space relations have been seized upon with such perfection, and as a rule the old masters succeeded in

Le Bureau de Coton, New Orleans. Oil, 1873.

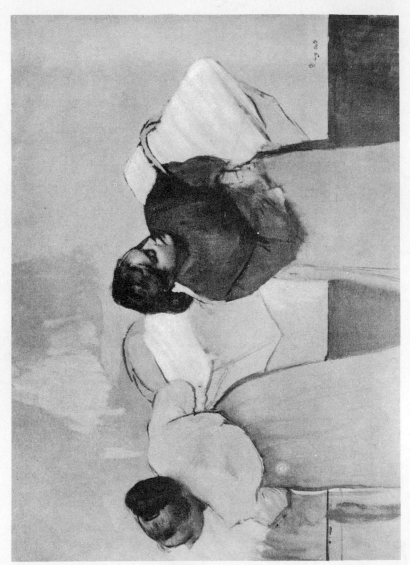

Les Blanchisseuses. Oil, 1879.

attaining such perfection only by employing means naturally more suited to this purpose. There is no difference in principle, though a very considerable difference in practice, between an artist building up his perspective with avenues of columns or with commercial travellers, especially if he succeeds in building them up in such a way that his volumes acquire a personality of their own. In this picture Degas succeeded in producing foreshortenings of an amazing kind with a fold in a pair of trousers. There are not two figures or two objects on the same plane. Everything and everybody stand, lie, or sit there anyhow, just as the routine of office life demands, which the painter seems to have accepted in its entirety, exactly as he saw it. It is possible to count a dozen different planes; nevertheless, nothing disturbs the calm balance of the picture. The vision of the observer does not travel at once to the end of the perspective, but spreads evenly in all directions, and is carried upward as easily as into the spacious breadth, where it flits from detail to detail which serve as stepping-stones. The prose of an office scene is concentrated into rhymeless lyrics, in which hats and sleeves, the crackling of linen, and every conceivable form of motion—in a word, everything portrayed—becomes the bearer of a new rhythm, and this lyricism is not dependent upon any external suggestion, upon anything that is not visible in the scene portrayed. It does not project poetical elements upon the prose of this office, but it is a monument of professionalism.

Courbet may have attempted something similar when he painted his *Cribleuses,* which was shown, together with this Degas, at the International Exhibition in 1900. Courbet produced with three figures two groups which did not belong to each other. His figures stand in a room which contains no air, and in spite of their faithfulness to nature have the appearance of artificial beings. Courbet wanted to show how far he could go in giving plasticity to painted beings, and in the process he forgot his pictorial problem and produced nothing but an unimportant experiment. The same problem may have attracted Degas to try his hand at this difficult trick when painting *Le Bureau de Coton, New Orleans*; but by accident he went beyond the limitations of experiment, much in the manner of Flaubert, who studied the realities of his perspective with the same exactitude, and who succeeded in creating, in spite of the amplitude of his materials, far greater values than seemed to lie within the mosaic of the material he had chosen. The genesis of such works may be arbitrary and will always seem less natural to us than the instinct of

a man like Manet. The ordinary observer will not be able to suppress altogether his surprise at the far-fetched nature of the problem—not because the painter has chosen an office, but because of the attitude he has brought to bear on the problem of volumes and space, and the way he has submitted to the accidental demands created by the details represented. No matter how far-fetched the problem and the solution may be, it does not assume a sufficiently important place in the mind of the observer to endanger his enjoyment, which does not attach to the objects themselves, but becomes a component part of the subjectivity of the painter, which we have to accept. The peculiarity of the result which has been achieved suppresses in this case, as in all others, the possibility of criticising the strange nature of the artist's conception. We experience similar sensations in the case of *Vicomte Lepic* painted at the same time: a view of the Place de la Concorde, with Lepic, his two daughters, and their greyhound placed in the very foreground of the picture, and the immense space stretching behind it, which, by its vastness, almost strikes terror into the heart of the observer. The series of ballerinas ascending from the souterrain to the stage, in the Camondo Collection, supplies, perhaps, another instance. The most daring tricks of the old masters seem clumsy by the side of the spiral staircase in the *Leçon de danse* in the Blanche Collection. The mere thought that it could be necessary for an artist to master these complicated problems of space and value would be intolerable, but the sense of actuality which Degas possessed makes such an idea bearable, though it is a gift of an intellectual rather than of an artistic nature. The assurance with which the solution is found is none the less admirable. The treatment of volume in the various dancing lessons of the Opera pupils—somewhat similar to the treatment in *Le Bureau de Coton, New Orleans,* although even grander— ennobles the subject. In the famous picture in the Camondo Collection, *Le Foyer de la Danse,* which began the series in 1872, the vast yellow hall gives to the pettiness, made apparent in every figure, a touch of dignity; in the other chef d'œuvre of the collection, the so-called *Classe de Danse,* with the white-headed ballet-master in the centre, the room, built up with cool green walls, gives gaiety to the detail. This treatment of volumes, astonishing though it is, is not capable of achieving anything more. These very pictures in the Camondo Collection, to which we might add, as a third, the variation in the collection of Colonel Payne in New York, were the chief means of supporting the mischievous idea that Degas wanted to be a kind of

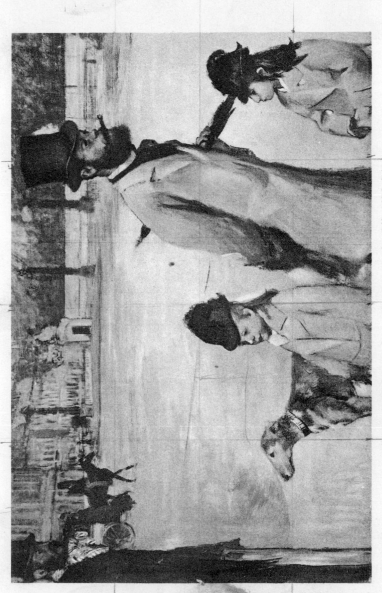

Place de la Concorde et Vicomte Lepic. Oil, 1873–74.

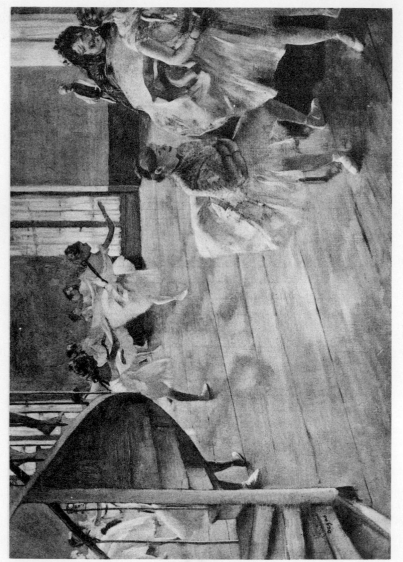

La Répétition. Oil, ca. 1875.

Meissonier. True, the descriptive element in the pictures is ample. There is not a line in the faces, not a movement, not a detail in this *Foyer de Danse,* which possesses such a wealth of detail, that is not taken from life. The famous ballet-master, Mérante, who will still be remembered by aged *habitués* of the opera, in his white linen suit, conducting with his arm, his violinist at his side, all these details, every attitude of the practising or resting dancers, have been placed upon the canvas with the utmost faithfulness. Generations of light-footed ballerinas have seen the severe but just Père Plucque of the *Classe de Danse* resting in this attitude on his ballet stick. In a history of the Paris ballet these pictures deserve a place of honour, and they would tell more of the life of these poor tortured beings, who angle with their toes for the great fame of a few of their more gifted sisters, than whole volumes could do. Here Degas was at home. Edmond de Goncourt visited him at this time in his studio, and he found an expert who was familiar with all the rules and the idioms of the ballet. "It was very funny to see him explaining his ballet pictures with choreographic phrases, mimicking occasionally an arabesque, and stranger still to notice how he mixed the æsthetics of dancing with the æsthetics of painting, and at the same time he would speak of the soft-brown of Velasquez and the outlines of Mantegna." Goncourt describes him in his Journal as: "Un être éminemment sensitif et recevant le contrecoup du caractère des choses." This phrase is extraordinarily true, truer even than the able observer ever realised, for it contains also the negative criticism of this "copie de la vie moderne." We have already discovered the same reaction to a specific world which he painted, the same "contrecoup du caractère des choses" in his sporting pictures. It was the same quality which made him so familiar with the things he painted. It was his love of novelty which carried him away; these qualities made of his pictures a kind of professional extract from his acute observations. Once more the artist gave place to the specialist. In Goncourt's description—of course, quite unconsciously on the author's part—the case of Degas assumes an almost pathological aspect. His realism escaped from its loose shell of abstract artistic principles and turned his playfulness to serious earnest. The artist whom we saw developing from a sporting painter into a sportsman now developed into a dancer.

He retained, however—and herein lies his seductive power against which even criticism is defenceless—a vision which is altogether unique in its objectivity, by which he gave to intermediate artistic

processes effects which hitherto had never been suspected. The artist, not the psychologist, was carried away. In his sporting pictures, his peculiar kind of psychology could give him only trifling assistance, and his cool reflection only presented an obstacle to him, because all intellectual analyses failed in the purely artistic representation of what we call landscape in this connection, but the minute there was a chance of discovering hidden human forces, it gave him a brilliant weapon. These people in tricot and gauze must have been familiar before the day of Degas to people who were acquainted with the footlights; the hidden humanity Degas brought to light was there and could have been discovered even by a layman who regarded the stage only from the auditorium. No one has ever documented them in such a permanent form. The simple contrast between the activities before and behind the curtain, the smiles of the elegant performers and their animal yawns in the wings, created a glorious procession in the realm of human expressions. What was so striking was the very simplicity of his intention, to portray expressions only as he saw them, without insisting upon any deductions, and to show the smile destined for the auditorium together with the tension of strained lips; to reveal the undisguised grossness of their private and unpaid-for movements, the nakedness of their thinly-covered limbs, in which the muscular structure of an ostrich's leg was made visible.

People have called this world ugly. If the ugliness had lain in the intention of the painter, its effect would be transparent, and it would soon have lost its charm. There is, perhaps, a certain subjective ugliness in some of the brothel scenes which Degas used for his monotypes, scenes which belonged rather to the artistic world of a Rops, although of course, far superior to it. They owe their ugliness, in spite of the simplicity with which they are drawn, to the fact that their author is unable to conceal his enjoyment of the spectacle he portrays. In his pictures of dancers we feel much more convinced of his objectivity. The ugly element exists only as a fiction, by the side of the fiction of the prettiness of a mimicry, which demands from the dancers that they shall move on the tips of their toes and smile, and display their rounded limbs and make them appear like pillars of stone.

Degas portrayed the unbridled expression after the dancers let fall their mask with the same coolness and professionalism as he showed the strictly regulated play of motions of these tortured puppets. Very often we can see something of the life on and off the stage in the same

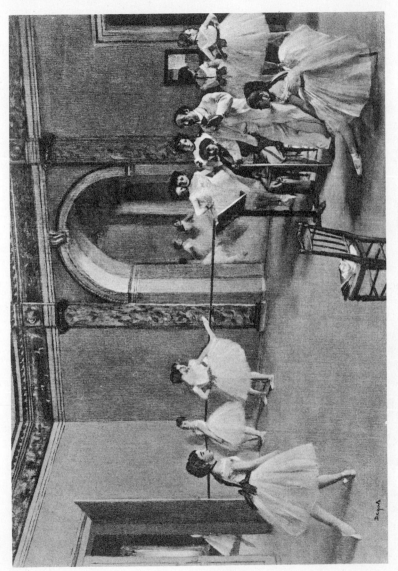

Le Foyer de la Danse. Oil, 1872.

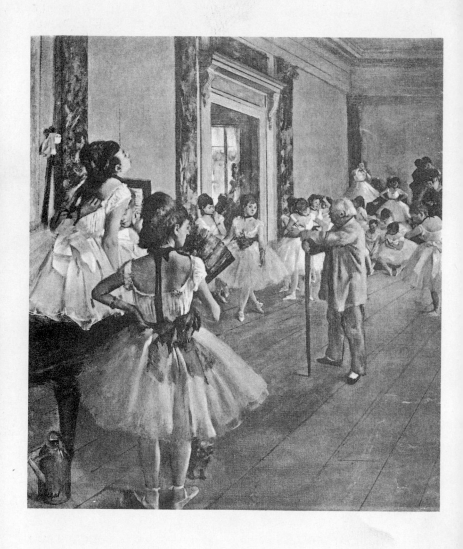

La Classe de Danse. Oil, 1872–73.

picture. The stereotyped elements in the animal nature of these dancing creatures is not without a certain splendour, which their dancing, as seen by the man in the auditorium, entirely lacks. There are movements such as we see in dogs when they scratch themselves, or in tired racehorses when they are being led home. The careful observer will not fail to notice the wealth of the mechanism of limbs in the movements and postures Degas has given us. What we are justified in speaking of as ugliness in many ballet pictures of the early Degas period does not depend on such details which, on the contrary, make visible new sources of beauty, but it depends, as it does in his sporting pictures, on the imperfect æsthetics of the picture. Admittedly the powers of resistance of the ballet painter have grown considerably. They seem to have grown in proportion as the wealth of newly discovered details in his new sphere has exceeded the domain to which he had devoted himself previously. Nevertheless, the difference between the capacities of the painter and the passion of the analyst for new discoveries remains noticeable, and at times it becomes emphasised to such a degree that it spoils our sense of enjoyment. In his *Foyer de la Danse,* which has been discussed above, he was content with the harmony between the white of his dresses and the yellow of his walls. This very modest palette would suffice if it had been supplemented by tones taken from the colours he employed, if the painter had managed somehow to enlarge upon the mere facts of his vision. In his later *Classe de Danse* he attempted to achieve more. This picture is much richer in colour, richer in the manner of Menzel's later colouring, and in this canvas of Degas' there are once more many details—for instance, the marvellously drawn ballet-master—which remind us of the German artist. Their wealth adds splendour only to the details and not to the whole of the picture. The gaiety of the many blue, green, yellow, and especially red bows, delightful in themselves, has been imported into the picture from outside, where for all his efforts it still remains.

In the most curious picture of the series, *Répétition de Ballet,* also in the Camondo Collection, the colour is almost entirely suppressed. The white of the dancers and the brown of the theatre supply the only contrast, and this contrast is confined to the substance. One cannot understand why the picture was painted in oils, why it was not simply drawn in black and white, for its essence is the drawing, and Degas was obviously only intent upon the minutest precision in modelling. The error of judgment which he betrays in

his choice of materials in this case explains, perhaps, the unfortunate mixed character of the picture. The dancers in their chalky white, whose plaster-like quality is hardly softened by the slight bronze-brown tones in the shadows, look like mobile puppets which have been photographed on a brown background. I would not even go so far as to say that this effect was not unintentional. Degas was an en-thusiastic admirer of photography, whose development he followed closely, and he took brilliant photographs himself. There is a photo-graph taken by him of this very picture. Viau possesses a very fine proof, and the photograph is more pleasing than the picture because it supplies an intermediary tone between the painted figures and their background. The problems of volume are solved in this picture with extraordinary mastery. We feel the depth of this extensive stage, the shadows of the wings, etc., but we are tempted to believe that the same effects might be achieved in a particularly good photograph, which has passed through the hands of an able retoucher.*

When we contemplate these plaster puppets we understand Degas' inclination towards sculpture. By that time he had often modelled small figures. At the first Impressionist Exhibition in 1874, at which he showed several pictures, amongst others the *Répétition de Ballet,* there was a small sculptured ballerina made of wax, which he had dressed up with gauze, etc.† This kind of statue has been fashionable from time to time. The little figure could be seen in his studio for many years after the Exhibition, and it was smashed, I believe, in the course of his last removal. Degas as a sculptor also misjudged his material in so far as he employed alien substances to give life to his work instead of depending merely upon the pressure of his fingers upon the wax he used. At a later period he is said to have found sounder methods, and I am told that he produced a number of very charming figures. I have never seen one, and I do not suppose it will be easy to see them even later on.‡ A friend of his told me that he made

*It is an altogether open question whether Degas did not, in certain cases, make use of photographs.

†Visitors to the Exhibition do not remember this statue, because it was only exhibited for half an hour. Degas had exhibited the pedestal for the figure from the beginning, but he did not bring his statue, so Renoir told me, until half an hour before the close of the Exhibition, and he was not a little annoyed when his request that it should be prolonged for some days, on account of the figure, was refused.

‡*Translator's Note:* Mr. Meier-Graefe had completed his book before the exhibition of M. Hébrard's casts of Degas' figures. The first exhibition took place in Paris, and at the time of going to press a number of these casts is on view at the Leicester Galleries, London.

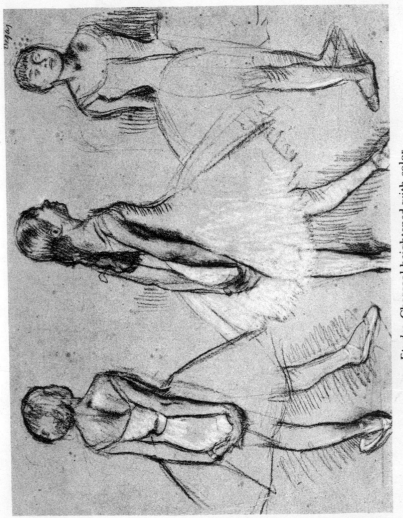

Etudes. Charcoal heightened with color.

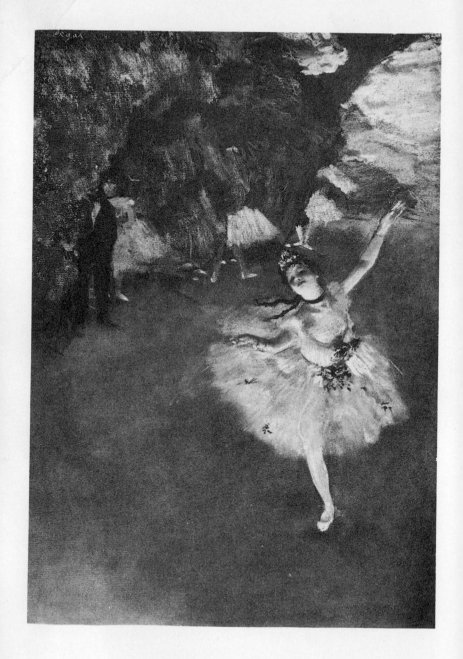

Le Salut au Public. Pastel.

an admirable bust of a painter who was for a time a kind of pupil of Degas. The bust in question was never completed, because the model, in spite of all his veneration for Degas, found the task of sitting to his founder more strenuous than he could bear. Hébrard, the caster, attempted years ago, but quite in vain, to obtain permission from Degas to make casts from one of his models, and I am told that of the large quantity of sculpture he produced—after his sight began to suffer he occupied himself almost exclusively with sculpture—there is only a very limited number of finished pieces, and a large number of studies.

Degas painted a variation of the *Répétition de Ballet,* which, though similar in size, was very different in treatment, and the picture is now in an American collection. It may have been painted just before the picture of the same title in the Camondo Collection, but it is conceivable that it was produced rather later. The stage is more or less the same, although the field of vision is reduced even farther, so that we see the pillar in front of the stage instead of the rounded rampart of the proscenium as in Count Camondo's picture. The same producer is seated in his top hat, but he has acquired a companion, who is making himself comfortable with stretched-out legs. Several of the dancers to the right are painted in the same positions as in the main version of this picture. The bench is there, too; in front of it is the ballet-master, who is conducting the steps of a dancer with both hands. In the foreground on the left, a row of dancers is cut in two by the frame of the picture, and right in front, the necks of two double-basses stretch up above the boards of the stage. This picture has been painted more rapidly than most. The dancers no longer resemble plaster puppets, the whole scene seems fuller of life, although the movement in the individual figures is no greater. One might be inclined to explain the difference by stronger development of pictorial qualities, and certainly the picture is richer in artistic effect. At the same time, the brush has little or nothing to do with the change, nor, for that matter, can it be traced to the colouring. The effect depends upon the extraordinary angle from which the field of vision is chosen. It seems to have been chosen quite haphazardly. An observer who happened to be lying on his belly immediately before the rampart in front of the stage, on a level with the enormous necks of the double-basses, might conceivably behold what Degas has depicted, provided his vertebræ were sufficiently supple, or else a camera might have taken such a snapshot if it had been lying

somewhere about the floor by mistake. Nevertheless, this apparently haphazard choice succeeds in creating in us an undeniable impression of probability. We are tempted to place a high value on this picture because it possesses a vitality which the puppets lack. If the aim of art is to reveal to us the objects it portrays from a new angle of vision, then we have before us a great artist. The decision of this problem will depend upon the answer to the question as to what this visibility reveals, whether it gives us, as well as the visual object, an essential clue to the artist, or whether it directs our attention more forcibly to the object itself. Objective qualities are always ephemeral actualities.

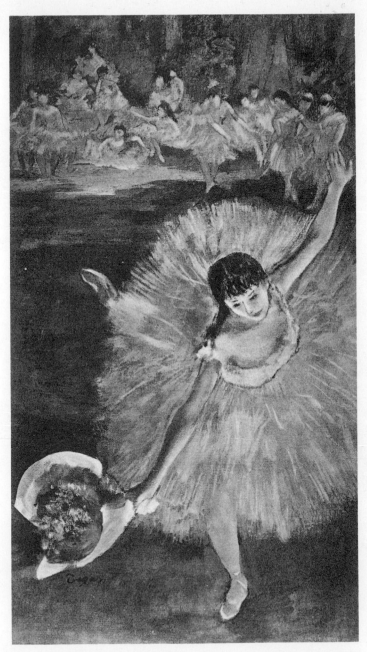

Le Ballet. Pastel.

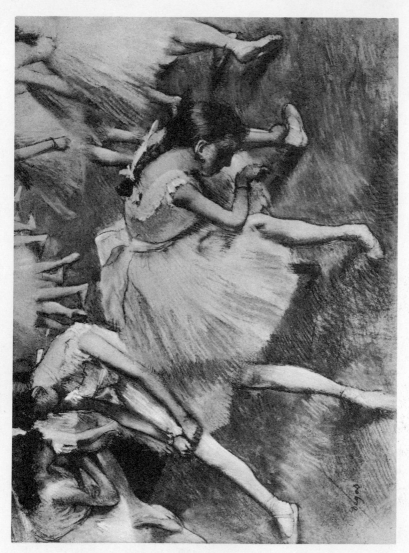

Danseuses. Pastel, 1879.

CHAPTER
VI

IN his essay on Degas, Liebermann has made a brilliant observation about the artist. He writes: "The first impression created by the pictures of Degas is that created by a snapshot. He knows how to compose his picture in such a way that we do not notice that it is composed at all. . . . It is easy to recognise every picture by Degas from a distance by the peculiar angle from which he chooses his field of vision. He quite boldly permits us to see here only a head, there only the hind-legs of a racehorse; suddenly he cuts into the structure of a stage with the extremities of a double-bass, and he does this with such assurance—in exactly the right place—that we imagine that it is impossible to arrange the component elements of the picture in any other way. . . ."

Degas, by the acuteness of his vision, has seized upon a point of view with which we have become familiar from photographs. His pictures, even when they are unsuccessful, have an almost anatomical professionalism, which never fails of its effect. His pictures and his drawings are documents, and in the creation of their impression the field of vision plays an important part. He appears to regard his scenes and his models as it were through an immensely powerful lens. The apparently ruthless manner in which he arrives at the selection of his field of vision would appear to support our belief that what we see before us somehow has a mathematical basis, and must, therefore, be correct. This effect is accompanied by certain decorative powers, which combine to give us the impression we receive in its entirety. This manner, when Degas first adopted it, was entirely new and

opposed to all custom; it offended, moreover, against the canons of the classical tradition from which Degas had started. Nothing could be more alien to the old severely architectural method of seeing the composition from a central point of view at right angles to the visual plane. This novelty was a gift which the East gave to Europe and Degas was amongst its earliest recipients. The entry of Japan into the realm of our art is now some seventy years old. Braquemond, the etcher, a friend of Manet and Degas, discovered one day in the year 1856, according to a story of Léonce Bénédite,* a curious volume in the possession of his printer, Delâtre. The pages of this volume were covered with strange handwriting and curious coloured pictures. The pictures also resembled a foreign handwriting. You saw half of a queer boat, which seemed to be growing out of a landscape which looked as if it had been forged out of one piece; you saw the apex of a cone, on top of which there were a few white blotches. There were bridges which extended from somewhere or other over an immense smooth blue plane. Braquemond allowed Delâtre no peace until he had given him this book, and from that time he carried it about with him like a talisman. He showed it to all his friends and interpreted its weird pictures. The boat was a boat in motion, the cone a mountain, the white patches were snow, and the bridge stretched over an expanse of calm water. He even knew the name of the author, Hokusai, or some such name, a wise old man of Japan who had lived for about a hundred years, and had devoted ninety of them to drawing. He had died not long before, just after he had learnt to draw a complete face with one stroke—ovals without mouth or eyes, which were more vital than all the portraits of the Paris academicians put together. The most extraordinary stories were told, but no matter whether they were fables or not, the prints, which everybody could see and touch, made incredulity impossible. The gentle methods of these drawings contained a criticism against the whole of the European apparatus,

*Gazette des Beaux-Arts, volume 34, page 142. Compare also the essay by the same author on Braquemond in Art et Décoration, February, 1905. The beginning of the artistic influence of Japan is generally dated from the International Exhibition in London, 1862. Seidlitz in his History of Japanese Colour Prints (Dresden, 1897, page 26) also dates it 1862, and traces its first discovery in Europe, as Chesnau does also, to the Japanese shop in the Rue de Rivoli, where the prints were found by artists. This shop, as Braquemond told me, was called La Porte Chinoise, and was conducted by a dealer called Soye. It was in this shop that Braquemond, Whistler, Burty, Manet, Duret, etc., met each other. It is by no means unimportant to note that this new conquest, like all great discoveries in the realm of art, was made by artists.

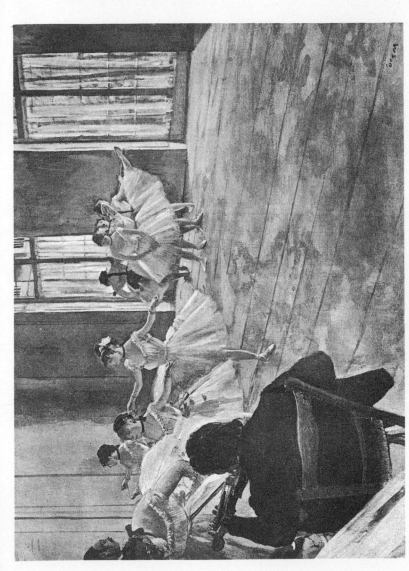

La Leçon de Danse. Oil, ca. 1875.

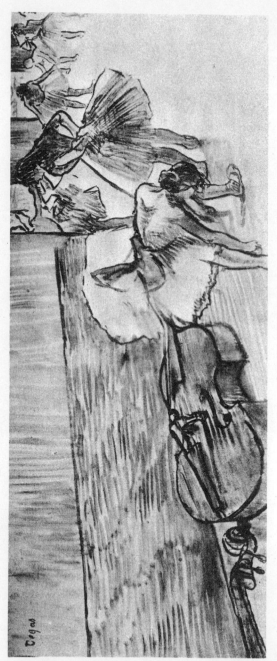

La Leçon. Oil.

against its subjects, against its sensitive pathos, and against its complicated technique. These drawings seemed to say, "Why all this fuss?" Surely the merest fragment of the means employed is sufficient to achieve more far-reaching results. The individuality of each of these drawings was not written all over them like a crude label as in so many European pictures. It depended least of all on the subjects used, but it seemed somehow or other to be connected with the merest pressure of the tiny brush, just as the weight given by a writer to his pen distinguishes his handwriting. If you examined the drawings carefully, you discovered certain similarities in Hokusai to the drawings of Rembrandt. Gradually the work of other Japanese artists became known, whose drawings gave rise to new discoveries, the elegance of Harunobu, the proud outline of Utamaro, the dignity of Kiyonaga. The impressionists of that generation suddenly realised new possibilities in the use of line drawing, which they had so much despised. The artists who made this discovery had to own, not without shame, that these modest people in the East passed through phases of artistic reaction just as they did, with the difference that the same process was arrived at by more professional and more economical means. Problems which in Europe caused agonies of labour were solved in this far-off Eastern island with a smile.

The surprise of the few Parisian artists of that day, who were initiated into this new discovery, could hardly have been greater if suddenly connections had been made possible between Europe and the inhabitants of Mars. The ethnographic differences which puzzled the public, presented no difficulties to the artist. A certain similarity of tendencies was recognised, especially those which happened at that moment to be engrossing the attention of the most progressive painters in France, and for that reason these tendencies were accepted as valid.

The art of Japan could only have been discovered in Paris. The necessary combination of conditions could only be found there. Paris recognised in Japanese art, amongst other things, the possibility of an easier, freer method, which corresponded more naturally to its spirit than the school of Fontainebleau or the solidity of Courbet. The most distinguished collectors and literary exponents of the Dix-huitième, the brothers Goncourt, were among the first disciples of Hokusai and his predecessors. The influence of Japan was more decisive in its effect on the revolutionary part of the impressionist programme than anything which Monet and Pissarro had experienced in front of

Turner's pictures in London. The critics of the impressionists, Burty, Astruc and Théodore Duret, became the "avant-garde" of Japan. In 1871 Duret went with Cernuschi to Japan and made then the basis of his beautiful collection. Zola based his defence of Manet on the "élégance étrange" and the "taches magnifiques" of Japanese woodcuts.*

Japan helped Manet and his friends to modify the landscape of 1830, and to loosen the toughness of the traditional *matière;* in fact, this process of loosening was the usual, and in some cases the somewhat dubious, effect upon many of the new admirers of Japanese art. The mobility which the Japanese gave to their compositions and their flatness led many, Whistler for instance, astray. In the case of others the effect was reversed. Opposition to the system of the classicists was at once strengthened and softened by Japanese influence. The fear of solid outlines was lessened in some cases, while others made a fetish of it. In order to reveal the far-reaching extent of the beneficial effect of Japanese influence, we must include all French artists from Jongkind to Bonnard, and among them even such contradictory personalities as Degas, Gauguin and van Gogh, and even a number of the later neo-impressionists. The vehicle of an influence which became so general was the coloured surface of Japanese art, the joy these wood-cutters betrayed at pure, or, at any rate, undisguised contrasts, and it was this revelation which led to a profounder understanding of what Delacroix had to teach us on the subject of colour. It is a paradox in the history of art that the most important result achieved by Delacroix came to be understood only as it were through the medium of Japanese colour-prints.

My friend Jäger, who played a small part in the introduction of Japan to Europe—he acquired his collection of Japanese prints, of which many passed into the possession of Bing later on, not in Japan, and not from European art dealers, but among a heap of imported goods in the Magasins du Louvre—had made up his mind at the beginning of the 'nineties that Degas should receive him. This undertaking was not an easy one, especially for a stranger. He made a bet that he would not only talk with Degas, but that Degas would

*The essay written in 1866 appeared first in the *Revue du XIXᵉ Siècle* in the issue of January 1, 1867. In the same year it was re-issued by Dentu in book form. The passage referred to, page 74 in the booklet, is probably the first occasion in the history of European art on which the influence of Japan was mentioned.

show him the whole of his house, which was full of treasures, and he won his bet. Degas really received him, and allowed him to pass several hours in his holy of holies. Jäger confided the secret of his success to me. He had taken two folios with him; in one of them were a few drawings by Ingres which he had borrowed, and in the other a dozen of his best Japanese colour-prints. The Ingres gave him the entrée into the living rooms in the Rue Victor Massé, and the Japanese colour-prints unlocked for him the doors of Degas' studio.

No one needed the gift Japan bestowed upon European artists more than Degas, and no artist gained so much from it. In the case of Renoir, Cézanne and even Manet, the contribution of Japan represents one influence among many, and in comparison to this influence the broad foundations of their own art always predominate. Degas, and especially the mature Degas, is inconceivable without his Japanese inheritance. This influence in his work can be recognised as easily as that of Manet, and it seems, unlike Manet's influence, only to have helped him. Degas absorbed the exotic element, as if his nature had been preparing for it during his whole life. It helped his talent, his draughtsmanship, strengthened his Ingres-like line, and gave profundity to his Moreauesque habits, and it made, or so it would appear, the pupil of Ingres into a modern artist. It is this influence which brings to light the noblest powers in Degas, to an incomparably greater degree than any of the relationships which we have been able to observe hitherto. The relation of Degas to the art of Japan was from the very beginning based on complete understanding. Degas never in any way descended to the mannerisms of the Japanese fashions which followed. He succeeded in keeping all ethnographic peculiarities out of his canvases. His friend Whistler became a decorator who covered his pictures with Japanese rags, much as a traveller of little taste might decorate his furnished rooms. In his own case, Whistler turned the influence of Japan into a new style which delighted snobs, and he betrayed how far the concealed pre-Raphaelite was below the concealed Ingres pupil. Degas did with Japan what Manet did with Spain. His love was not lost in the admiration of mean delights, he retained his distance and never stooped to the very slightest imitation. He regarded the products of the strangers as he regarded a new model, which can only serve to supply new opportunities for increasing the artist's wealth of experience, and for this reason Degas brought unity into his work. The acuteness of his vision penetrated into the farthest corner of the strange science of these colour prints. He recognised the

rules of composition, the traditional forces which regulated the Japanese volumes which seem to be strewn haphazard all over the page, but he retained his mastery over his own powers of determinism. The result he attained was a personal gain and raised him to a new level of achievement. The same artist who has demonstrated, to a greater extent than anyone else, the value of what the Japanese can teach us, has helped us to recognise the limitations of their art.

As long as the Camondo Collection was hanging in the house near the Opéra, you had to pass through an ante-room filled with Japanese prints before reaching the Degas Collection. You could see there the loveliest Harunobus, Utamaros, the loveliest actors' heads by Sharaku, etc., which used to belong to Manzi. The admirable display of the rich collection, the sequence of these rooms, first the Japanese collection, and then the pictures by Degas, was certainly no accident. It was a pleasure to be in both rooms, each of which was unique in its way, but visitors to the house did not carry with them any impression in passing from one room to the other. The arabesques on the walls, and the wicker tea-tables in the ante-room formed a world of their own, a curiously peaceful world. Although many artists were represented, whom, in their own country, no child would fail to distinguish, and whom we, too, have learned to differentiate with ease, there was a curious quiet unity dominating the room. The many lines did not lack mobility; in fact, everything which one beheld was swayed by a delicate motion, but the motion was, as it were, of a platonic variety. The various types did not offend against each other, nor did the whole effect offend against the most delicate sensibility in the observer. The element of motion was not aggressive, it seemed rather to have a kindly smile for the visitor. As soon as one entered into the Degas room, if one thought of them at all, the many Japanese artists in the ante-chamber lost their individualities and became merged into one entity. The room which contained the works of only one artist, however, became the field of battle for many sensations, as if in this place a large number of people were struggling against one another. Even pictures which possessed a calm of their own challenged us either to approval or dissent. The drawings in the ante-chamber were, perhaps, better in their way, for they fulfilled their purpose to perfection within their own limits. You did not find among the Japanese the glaring contrasts between success and failure. Count Camondo possessed the richest, and, as showing the development of the artist, the most important, but not the best Degas

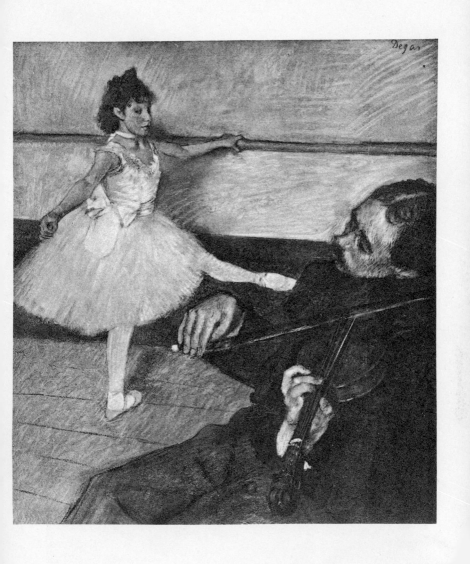

La Leçon de Danse. Pastel, ca. 1878.

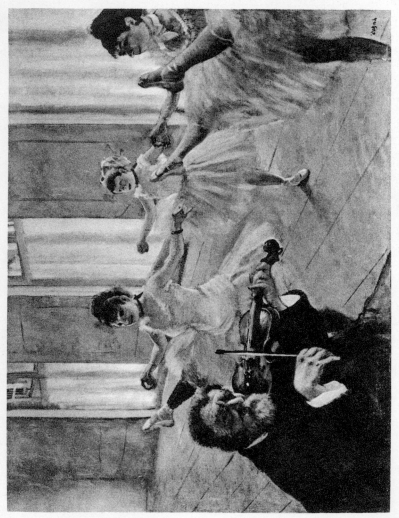

Répétition. Oil, ca. 1879.

collection. His collection does not hide the dangers which beset the artist. Though he possessed the most famous works by Degas, he had too little space for the unchallengeable successes of the master, but nevertheless, this collection gripped the visitor in quite a different way from the charming drawings in the ante-chamber. Their contemplation suggested efforts which never wrinkled the brow of any Japanese, and it makes us understand that Degas was forced to vacillate as he did because his aim was placed so high. His whole outlook is on a higher level. The economy of means with which a man like Harunobu achieves his effect is worthy of admiration; the result, however, hardly approaches the horizon beyond which we must look for the aspirations of Degas, aspirations which we regard as the only sphere worthy of the traditions of our past. There may be certain traits in the manner of Hokusai which resemble something in Rembrandt. Edmond de Goncourt may be reminded of qualities in Michelangelo by Japanese calligraphy, and certain of our primitives may suggest other not unreasonable comparisons, but this is not sufficient to remove the immense difference in the real content of their respective works. It is characteristic of the looseness of the æsthetics of our day, and of the decline in the quality of our judgment, that many friends and students of art allow their boundless admiration for Asia to confound their recognition of the values of these two different spheres of culture. They explain this difference by reference to merely superficial factors, by saying, for instance, quite unblushingly that the art of oil painting has, for purely external reasons, remained a closed book to Asia. One of the results of this erroneous liberalism is to be seen in the manner in which the younger of our generation of artists seek justification for their work in the products of primitive nations. They claim the right to be permitted that which was not forbidden to negroes and kaffirs; they forget the difference between the ante-chamber and the inner room. The artists of Japan were saved the struggle of the artistic achievements which our culture brought in its wake, hence their enormous advantage in the arts and crafts. This explains also why a netsuke carver, whose family has produced mice for generations, could say in all earnest to a traveller who happened to see him at work and wanted to buy the finished article, that he would be busy at his mouse for another two years because he experienced true inspiration only rarely. The history of Japanese art is rich in similar anecdotes. On the other hand, its history is barren up to date of the great universal phenomena which lie beyond the realm of arts

and crafts. We owe to this difference not only the struggle between our various forms of artistic expression, but also the creation of the greatest symbols of our race. It is the expression of our relation to the cosmos, which may be more dramatic and more tragic than the wisdom of the East, but as the cradle of a nobler conception of human destiny it implies an infinitely higher standard. Even if our art should finally go to pieces as the result of this struggle, we could wish no other evolution for it.

Degas appears to us, rightly or wrongly, to be the most typical European amongst modern artists. He attained in a curious way to the sum of the representative peculiarities which we mean when we refer to his Europeanism, but he did so only after he came under Japanese influence, and it is precisely the results which scientific analyses might ascribe to this influence which we regard as the peculiarities of this representative of European art. His peculiar angle of vision is Japanese, though nothing seems to us more European to-day, so perfectly does it correspond to our own point of view. This attitude was not determined by retrogressive suggestion, by familiarisation with a foreign concept, but by psychological factors which seem primary by the side of the concept, but which in reality create it. Our modern field of vision resembles his exactly—to-day. We live within the concept which Degas invented—must live in it if we are not to be swallowed up in the whole. Our nerves demand it. In literature we are presented with the same phenomenon, the same field of vision, the same bold stroke which places us at once in a scene of action, and carries us to an equally sudden end. We demand of our drama that it shall appear to be haphazard, apparently so unpremeditated that its underlying idea shall emerge like the fundamental motive of the human being it deals with, and that the individuality, the most personal element, shall seem to be only a link in the chain of our imagination. We would like to express ourselves as undramatically as Degas, in whom we feel the reflex of Japan; we, too, would like to find a way so free from sentimentality, so calm in its lack of premeditation, a way whose approach is made from the curious angle of Degas' field of vision. We acclaim those who succeed as good Europeans.

The most remarkable effect which Japanese influence had on Degas was upon his volumes. Nothing was so opposed to his education, his talent and his tradition as the flatness of the Japanese, which so delighted Manet. We would never have imagined that our

Frenchman, a pupil of Ingres, would have given way on this point. While his comrades had recognised the necessity for this essential change in modern painting, while Claude Monet went into ecstasy at the idea of resolving visual objects in sunshine, Degas forgot everything in his search for realistic solidity in his figures. His tendency towards sculpture led him even so far as to exchange his brush for clay. It took a long time before Degas discarded these last remnants of his academicianship, which were to him the symbol of his dearest memories, and the profundity of his opposition may explain the strength of his later drawings. In his most mature period he attained to the understanding of the recession of planes, not as Manet and Monet did, not as a painter, but as a draughtsman, and in this way he absorbed in his own way one of the peculiarities of the Japanese, which has ever since been the red thread that passes through the history of European art; and it was by this means that he carried his eventful career to success.

THERE was one thing which Degas could not learn from the Japanese, and that was how to paint in oils. While his composition and drawing developed rapidly, the craftsmanship of his painting lagged behind to an extraordinary degree. The mere fact that we are able to differentiate between these elements in his paintings is a criticism of the painter. We feel in almost all his oil paintings a certain resistance in the *matière,* to which Degas devoted either too much or too little attention. Somehow the whole of his means, or shall we say, all his means, did not seem to be suited to his aim, and in those cases where his skill triumphed over his rapidity, his success is achieved at the expense of the artistic merits of the picture.

These faults cannot be explained by lack of manual ability, nor by an insufficient sense for technical problems. Quite on the contrary, he was one of the most skilful technicians of modern art, he solved all problems of craftsmanship with playful ease, and was at home in every department of the arts. The graphic section of his work, which, unfortunately, is as yet too little known—here a gratifying labour awaits the admirable Loys Delteil—gives an insight into the technical abilities which supplement the painter in a most surprising way. Most of the leading modern masters have regarded the graphic arts as a kind of side-line, but Degas reveals his artistic aspirations in their purest form for the first time as an etcher and lithographer. The etchings on the whole belong to too early a period to play a decisive part. In general, they betray his dependence on other artists, but the moment Degas made his first stroke on stone he became a master. His

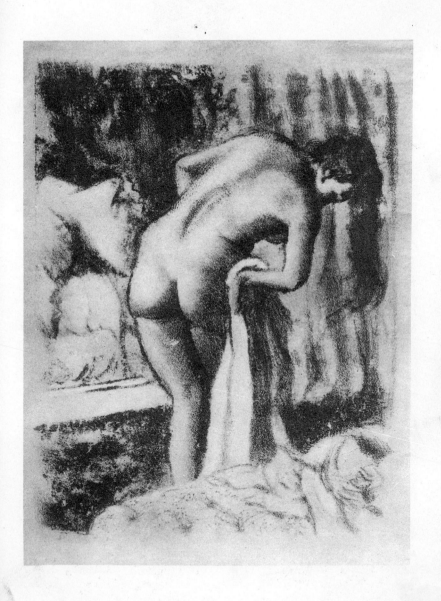

Après le Bain. Lithograph, ca. 1880.

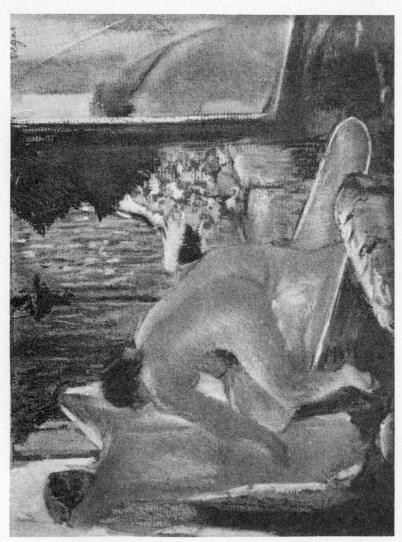

Le Bain. Pastel, ca. 1880.

lithographs are rare. I only know a few specimens which were collected by Doucet, Beurdelay and Roger Marx. Doucet has generously placed his valuable collection of Degas' graphic art, probably the most complete in existence, in his public library, and thereby made it accessible to the public. There are several lithographs of Degas' favourite subject—*Après le Bain*—a nude girl drying herself. On one of these sheets the figure is created only by delicate touches which represent the shadows of her form. In the background the ample *femme de chambre,* holding a bathgown, is suggested even more faintly. The whole creation seems to be breathed upon the paper. The formative elements in this drawing are confined to the closely grained grey of the printing ink, and they supply us with everything, that is to say, not only with material objects, human beings, with their faces and their nakedness, and the substance of materials, but they supply something which so often escaped Degas— an atmosphere of his own. All the material factors, even the fiction of reality, are laid aside, and a higher, surer existence is revealed. Degas never attained greater pictorial qualities in any of his richly-coloured paintings than he did in this lithograph, and he has never composed a painting to better purpose. The difference between colour and drawing ceases to exist here, and we are unable to praise his treatment of volumes—which seem to have been created of their own accord—at the expense of the unity of the whole drawing. The volume and arabesque are united. Compare, for instance, the very best Harunobu with it. The comparison is obvious. Similar motifs are to be found in many Japanese colour prints, but comparison would be far-fetched. The harmony of all the factors that go to make the effect is achieved to perfection in both cases. Nothing disturbs the balance in the Harunobu, nothing detracts from the atmosphere of the Frenchman, but the elements in the Japanese drawing, the perfect technique, the elegance, the decorative charm, are clumsy concepts compared to the qualities displayed by the European. They could be weighed in a pair of scales, if the scales were fine enough. Sensibility enters into the question. How could it be otherwise? Sensibility is a stupid word, which may mean much. Sensibility, in the case of Degas, and in the case of all great masters, is the quality which gives something to thei work over and above perfect technique. In relation to Harunobu t rôles are reversed. On the one hand, we have the qualities c craftsman of sensibility; on the other, sensibility itself, which a creates everything, including the necessary craftsmanship.

In another lithograph, which looks almost like a later state of the one described above, and which shows the naked girl without her servant, all the effects have grown in scale. The colour is deeper, like the darkest shades of velvet in the stripes of a tiger in a lithograph by Delacroix. The body is softly modelled only in planes, but is much larger and more powerful in its handling. A thick stroke forms the outline which was merely breathed upon the other sheet, and her hair tumbles down in a heavy black mass. The lithograph loses its graininess and becomes fat and luminous and almost like a *vernis mou*. Degas felt the need for a new technique. The depth of a lithograph was inadequate. He also wanted a more fluid *matière*, whose substance possessed the mobility of water-colour, and from which he demanded above all a richer effect of tone, and thus he arrived at his monotypes.

I do not know whether Degas could claim to be the sole inventor of this process, which his pupil, Forain, and others have since frequently used. Probably Lepic assisted him.* At all events, he turned this process into a most refined tool. The actual technique is very simple. He took an oxidised zinc plate, on which he put his colour, a smoky black. He then placed the plate, without etching it in the least, against his paper. As the drawing does not attack the metal in any way one proof only can be made from such a plate, and one ought not to call it a proof, but an original. The technical refinement depends upon the manner in which the ink is brought upon the plate. Degas varied his method in every conceivable way. He sometimes smudged the surface with his thumb or the palm of his hand, sketched the outline with a match or with his finger-nail, and used his brush whenever it suited him. Not content with this, he would sometimes take his pastel and add a touch of colour here and there. Sometimes he covered the whole sheet with pastel, thereby achieving an impenetrable effect which astonishes the expert.† At other times he was content with the simplest process imaginable. The *Toilette*, in the Doucet collection, the girl standing between her bath and her washstand, looks like a piece of paper that has been smoked over a lamp, and which by accident has retained a few white patches. The

*Compare Lemoisne, page 55.
†During the second auction after his death the series entitled *Impressions en* *leurs retouchées par Degas* (Catalogue No. 361–383), and another one entitled *...ssions en Noir* (Nos. 384–386) were sold. I have not been able to discover in what *...que these were made.

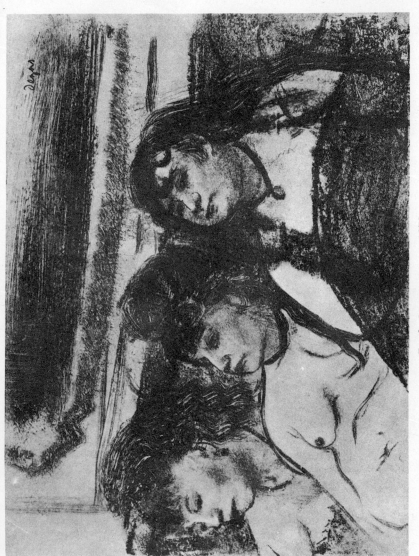

Etude. Monotype, ca. 1879.

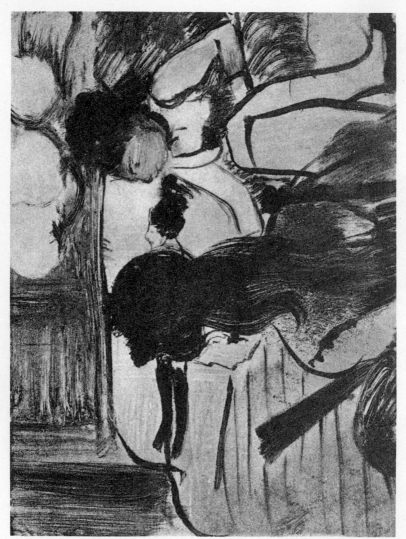

Deux Femmes. Monotype, ca. 1880.

ghostly clair-obscur effect is none the less an accomplished per-
formance, though it is nothing else. In another design in the same
collection, *Admiration*, the same black suggests every conceivable
substance and expression, including the bestial face, with which we
would have gladly dispensed, of the *admirateur* crouched in front of
the bath-tub. As soon as the technique became too easy for him the
result of his labours was very cheap. Many designs, which are more
comparable to water-colours, look like simplified drawings by Guys.
Most of them depict brothel scenes and the like. The resemblance to
the gentle art of Guys disappears beneath a caricature of sometimes
frightful coarseness. In such drawings his prostitutes appear like
machines with enlarged heads of mice and with movements like
insects. Similar subjects, when treated by Lautrec, who followed in
the footsteps of Degas* as a graphic artist, were modified by wit and
humour. His grotesqueness is more supportable than the cold
professionalism of Degas. In the centre, beneath an oblique gas
chandelier, half a dozen females sit upon an oblique sofa. Their
heads, huddled together like the gas lamps of the chandelier, form a
kind of bouquet. A few blotches, one can hardly call them strokes,
convey their faces. Everyone of them represents whole generations of
their kind. A greyish blotch above their heads forms the hair of each of
them, and the whole effect is plastic like the pillar of a temple.

People have compared Degas, the caricaturist, to Daumier, and he
has even been called the greater of the two. That is going too far. He
stands above Forain, and above Lautrec, and above everything and
everybody who belongs to this class, but not above nor beside
Daumier, who does not belong to it. Daumier is Molière, Degas a de
Goncourt. Even if we disregarded the painter in both men which, of
course, we cannot do, Daumier would stand out as a giant. His
laughter—not kindlier, rather haughtier—possesses a deeper sonor-

*Even the finer shades of Lautrec are to be found in the graphic œuvre of Degas.
Compare, for instance, the monotype of the circus scene with the clown and the dogs by
Degas, or the half-tone block of the drawing for a programme, dated 1884, violins,
dancers, etc. Both of these are in the Doucet Library. Lautrec's addition is confined to
an intelligent simplification. He has modernised and smoothed and loosened Degas'
decoration. He made himself thoroughly at home with lithography and became the
most skilled lithographer of modern times. His charming coloured lithographs,
although they belong so essentially to Paris, reduce the distance referred to above which
separates the art of Europe from the art of Japan. The addition which Lautrec made
would hardly have been valued so highly if the lithographs of Degas had been bett~
known.

ity, it might be pathos, it might make you shudder like the laughter of Shakespeare, but there is always music in the sound. In Daumier there is a greater play of light and shade in the contortion of his masks, a wider experience in his attitude, and a profounder tradition in his culture. Delacroix was his companion. While he bent over countless drawings—work to which necessity compelled him—there appeared to him the shade of Michelangelo from the farthest recess of his tiny studio. In those works of Degas which we can call caricatures, his greatness does not enlarge the extent of his horizon, it possesses the negative quality of everything that is unusual. We criticise his brothel scenes and similar subjects for the same reason that we criticised his sporting and his theatre pictures: lack of atmosphere. The word is not sufficiently delicate for the shade of meaning we intend. This lack does not challenge their intrinsic value, but it reduces their effect. If I make this criticism in connection with his atmosphere, I do not on this occasion refer to his pictorial qualities. The pictorial qualities are preserved by the loose texture of the monotypes. The events or figures represented are created before our eyes by means of patches, and the manner in which they are organised leaves no loophole for criticism. This recognition, however, does not satisfy all the demands of the observer. In view of our primitive means of defining beauty, we are reduced to eliminating the negative elements; higher considerations, such as the difference between Europe and Japan, cannot be formulated in an abstract law. Such laws can easily be fulfilled in painting if the content is not serious enough to present any opposition, when, that is to say, the artistic personality remains on the surface. In these monotypes we miss such opposition, the serious content which could have made them into works of art. Degas succeeded with a few strokes in presenting to perfection precisely that which impelled him to make these monotypes, but the forces which impelled him were too paltry, hence the effect of his few strokes is less great than summary. He always managed to convey the atmosphere of the objects with which he was familiar, but he conveyed much more rarely the difference between the objects themselves and their mental import. Apart from all prejudice for or against the milieu represented, this is the distinction which great artists have invented as an equation between a special case and generality. In poetry this equation is called humour, and that is what Degas lacked. His art and his nature forbade any profound participation, he stood detached from men and the world—an attitude indicating weakness. We could

also recognise the deepest impulse of the politician as humour if the word "politics" signified creative statesmanship, and in this way we can describe most accurately the abyss which separates Daumier, the revolutionary statesman, and Degas, the parliamentary dialectician.

There is something exotic in the monotypes. Degas' interest in the zoology of brothels sometimes overcomes his delight in the play of line and colour. Degas retained in this connection the traces of a daring bourgeois who permits himself a debauch, and at this point he approaches Rops, who broke away from the cloister of good manners. Constantin Guys found all these trivialities less important, and he perfected his design while making himself at home among his wenches.

The monotypes almost disappear in the expanse of Degas' work, they play a secondary part in helping us to form a judgment of its value, but they are nonetheless interesting to a research student, as symptoms. They represent an intermediary stage in the evolution of Degas, of his style and of his decoration, and they prepare the way for a decisive change. They stand somewhere between painting and drawing and also between youth and maturity, and give us the clue to an important step in the progress of his subjectivity. They represent the last, perhaps not altogether admirable, shortcut Degas attempted to make before he reached his goal. We cannot suppose that his monotypes could have engaged his attention for any considerable period. The ease with which the medium came to his hand must have made him dissatisfied before very long, but in the end the technique of the monotypes revealed to him the domain for which unconsciously he had been looking all his life. While he was engaged in bringing luminosity into his blacks, his contemporaries were covering their canvases with glowing colours. For some time he had watched the flaming of the palette of Claude Monet and his companions with his usual detached calm. He was openly suspicious of the catchwords which had been current ever since the exhibition of the new group, and he did not regard himself as belonging to them: in fact, he rejected the title of impressionist with some heat, but his intelligence recognised the virtues which the work of his friends contained, over and above actuality, and which he could employ to his own advantage.

Degas must have had least sympathy of all for his friends' rhapsodies over Nature, his whole being was far too detached to enter sympathetically into such ecstasies. He was not the man to accept the

merciless consequences, entailing sacrifice, of any fundamental recognition. Aesthetic considerations may have had more weight with him: the combination of Ingres with his opposite, Delacroix. Renoir, the enthusiastic disciple of Delacroix and admirer of Ingres, had attained to the pictorial merits of his early pictures by the use of the palette of the *Femmes d'Alger*, and he attempted in the 'eighties to solidify his structure by the aid of Ingres. Degas and he were friends at that time and perhaps it was not enthusiasm but reflection which impelled him along parallel paths; after this cold observer had put off his ancient foibles and remained for a time in thoughtful repose, suddenly luminous colours flowed from him.

A GREAT hour had struck for Degas when he completed his first pastel.* This sounds strange after all that has been said previously. It is difficult to imagine that the happy turn in the development of a master could be dependent upon a purely material accident. We are justified in being suspicious, especially in the case of a man like Degas, whom we have observed on many occasions searching for artificial means of assistance, instead of clarifying his vision. If it were possible to say that the adoption of the pastel crayon alone had placed Degas upon his height, we would fancy his position very insecure. The situation is rather different. His pastels did not seem to be the cause but the result. They are the result of his renunciation of painting, a decision which Degas reached towards the end of the 'seventies. From that date onwards he used his brush only on exceptional occasions. The renunciation is the important point. An artist who hides his weakness behind technical complications lacks the necessary perception to comprehend the ethics of pictorial evolution. The rejection or renunciation of an artist's attainment, which he has recognised as fictitious, is a sign of maturity and may lead to progress. We can easily imagine an artist whose development is impeded by the necessity of employing a technique unsuited to his talent, and who overcomes his obstacle as soon as he

*We refer to his mature period. Degas had made pastel drawings at a much earlier date. There is a pastel even for one of his earliest paintings, his *Semiramis*. This pastel was sold at the auction after his death, Catalogue 1, No. 219, and was also reproduced is a dreadful picture, reminiscent of certain smeary Turners.

he gives it up. It is rather more difficult not to regard the complex created throughout the centuries, called painting, which is produced by a brush, as the only proper sphere of a painter, because all the great masters have turned their brush into a magic wand. Nevertheless, no matter how we may twist or turn it, the brush remains a stick with bristles, a tool which is employed by every decorator's assistant. In the case of Degas the effects which are peculiar to this tool had proved to be unsuitable. It so happened that he combined with his painting an unattainable ambition to paint like Ingres. This is less remarkable than the idiosyncrasy of a poet, whose renunciation of his accustomed nib might imply serious sacrifice. In pictorial art the share of the tools, in the formulation of an idea, is so great that some people commit the error of mistaking the skilful application of the stick with bristles for the art of painting.

It took Degas more than twenty years to make up his mind to give up this medium, and the decision could not have been an easy one for an artist whose training and tradition were as conventional as those of Degas. Years ago, when he could still be approached by artists in need of advice, he was in the habit of fingering the pigment on the pictures they brought to him, and he only resorted to his spectacles when he could feel small roughnesses. Every form of heavy impasto was distasteful to him. He considered that a smooth surface alone could vouch for the possibility of quality. A picture which could not resist the centuries must be worthless even to-day. How difficult it must have been for a man with such a keen sense of craftsmanship to be content with a *matière* to which the slightest vibration spells ruin. To have confined an artist like Constantin Guys to water-colour would have reduced his artistic achievement to an insignificant affair. Daumier remained a lithographer in spite of all his pictures, and he had to suffer penury because of it, and now Degas was forced to the use of pastels. Drawing in pastels implied the Dix-huitième. La Tour had stamped this medium for all time with his sickliness. It was considered a *métier* for ladies.

All these considerations probably disappeared, like dew before the rising sun, the minute Degas saw his first series of pastels standing before him. They were the same creatures whom he had often placed upon his canvas, they bore testimony to many a prolonged agony. When he painted them they remained painted canvas, and the colour with which he sought to give them life weighed them down, but now revelled in newly discovered melodies. Restrained though he was,

Degas felt the ecstasy of his own created rhythm. His jockeys shone in the sunlight, and his dancers moved in the glamour of the footlights. They ceased to be the disembodied creatures who had escaped from the theatre, and became the heroines of his own stage. He was a draughtsman pure and simple. The outlines of his figures became the undisguised structure of his pictures. He suggested in large lines everything that lies within the domain of a simple stroke; he achieved a bold anatomy which revealed the pictorially effective elements of a mechanism of bones as if some magical X-ray apparatus were at work, and now, for the first time, the inventor came into his own. His pictures no longer reveal the psychologist observing the secret movements of a woman who fancies herself alone, or watching the motions of a dancer from a hidden position in the wings. The contrast between semblance and fact was no longer the impulse that made him paint. He now discovered between these contrasts, which had attracted him hitherto, the elements of his own expression. The simplicity of his intention benefited his expression. The bather who, with straining arms, tried to reach a portion of her back with her sponge, once she was within the confines of his picture, even if it was bare of all other design, brought a living arabesque with her. A dancer could be the means of conveying unqualified beauty if she was regarded only as a body in motion, and if every attempt at decoration, which did not contribute to the central purpose, was abandoned. The pastel crayon made it easier for Degas to make this sacrifice. The web of little strokes, which surrounded the main structure of his design, was no longer placed there in order to describe the surroundings or the background of his model. Without thinking of painting, he painted with his crayon better than he had ever done with his brush, and the result was motion which was truly created and creative. As soon as he ceased to make objects his isolated aim, something living was created consisting of colour which transformed his surroundings into a stage, into a bath-tub, or into a table covered with all kinds of objects, and which yet remained the strokes of an artist. A scheme of parallel lines sufficed to produce the back of his model, and in the places where the shadows began cross strokes of a complementary colour supplemented his design. Patches of less regular structure suggested textures and thin squares created the distance of the background.

At last our skilful technician discovered the world which was suited to his talent, and he became the master of it as no one else has ever

done, so that even Manet more than met his match. Here Degas became the giver and Manet the recipient. Wherever we have an opportunity of seeing the pastels of both artists side by side, as, for instance, in the Bernheim Collection in Paris, the *Danseuses roses* triumph with their gorgeous colour over the famous *Femme dans un Tub,* one of the very best pastels by Manet. Manet's work becomes empty as soon as he ceases to feel the resistance of oil paint beneath his fingers. It becomes empty and banal, like many of the oil paintings by Degas, for whom this very resistance proved too much. Degas invented a new kind of pastel drawing as Cézanne invented a new kind of painting. He has multiplied the possibilities of drawing in pastel handed down by preceding generations. His pastels consist of many layers. Every layer represents a certain stage in the history of this medium, and Degas superimposed a new layer, a new system of his own. Every other form of technique, really alien to pastel drawing— we have already mentioned his monotypes—assisted the artist in enlarging the variety of his medium. The great secret of Degas lies in his ability to preserve the appearance of transparency, in spite of the admixture of alien methods. Even in cases where ten layers lie above each other he has managed to make the structure of his lines apparent. He thus avoided the faded mistiness of the pastels of the eighteenth century, which are rarely better than clever reproductions. He invented new cadences. He only discovered this secret gradually. His early pastels lacked organisation, and their effect, in spite of his lightness of touch, is slight. The supposed bloom of the famous *Danseuses à la Barre* is in reality—that is to say, in its pictorial reality—shapeless, and in his pastels we meet the same phenomenon, which reminds us of the errors of Whistler. But even the early pastels are enriched by a better chosen exterior. Illustration for once becomes sublime. One can hardly feel its traces in pictures of the transitional period, such as the *Café* in the Musée du Luxembourg. I do not think that anyone will be able to resist the seductiveness of the drawing of the solo dancer in the same collection, even though its charm depends rather on the extraordinary skill of an interpreter than on the certain strokes of a creator. Degas' newly discovered technique was surely the ideal medium for the glamour of the footlights.

The development of Degas, the painter in pastels, was a rapid one. It did not take him long to see through the charms of a symbolism, which attempts to attain easy ideals by easy methods. The given properties of any medium mean nothing until a superior mental

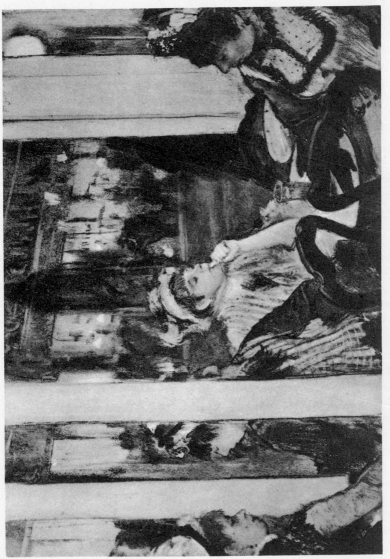

Café, Boulevard Montmartre. Pastel, 1877.

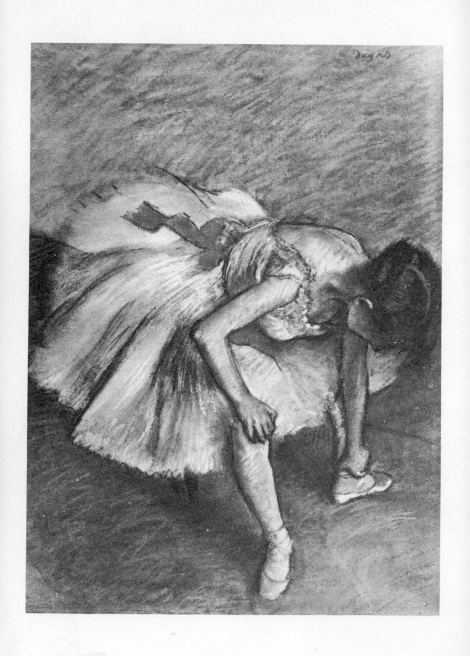

Danseuse. Pastel.

power changes them into contrasting equivalents. Degas was tempted to armour his medium with undreamt-of powers of resistance, to bring organisation into the arbitrariness of his coloured bloom, and to create, from the dust with which he fashioned his vases, weight, solidity and greatness. Thus, his fragility developed into a miracle. The traces of a crayon that barely touches his paper, and planes that can be blown away, suffice to create rich musical chords. We arrive at a point when we almost forget all technical problems. The psychologist builds up an image of his point of view from an innumerable series of analyses, if necessary even in violent contrast to everything that is fragile or lovely. There is an element of fierce pride in his anatomy. Not a trace of calligraphy, no vibrating outline, nothing Japanese, nothing from the Dix-huitième. If, however, our eye meets with a perfectly rounded shape, we may be certain that in its immediate vicinity we will find abysses and chasms. Degas stripped off his classicism in the riot of luminous colour. The substratum of bourgeois Empire was supplanted by a new conception of Gothic art, and what is Gothic in Degas is Gothic in the severest sense. Gothic line, but tenser, more jagged, more shadowy than any of the primitives of France, in whose products there is always the semblance of a distant smile. Gothic art without its fervour—Degas remains cold, even in intoxication. He displays glowing colours, but he remains personally untouched to the point of cruelty. Even in Ingres we sometimes feel, in the oppressive atmosphere of his harems, a certain coldness, and there is sometimes an insensitive hardness beneath his softest and most rounded forms. Degas rejected all softness, he seized an ankle, but not the flesh. The puppets which nestle together softly in Ingres, move by taut wires in Degas, and their motion is the dance of death. Not a sound emanates from his mummified faces. Bones have expressions and human backs are bent in anguish, arms howl and legs whine, while his machinery continues its motion. Women might be afraid of Degas, just as they smile confidingly before a picture by Renoir. Degas portrays another side of feminity. Nevertheless, a great wealth is concealed in this hatred, the anguish of an oppressed creation flames up in colour, the human animal is illuminated in the cold nakedness of Degas' treatment, and the dusk resembles the depth of a mighty chord.

His colour is not due to any rare form of pigment, it is simply fiery patches. There is something after all of Delacroix in this pupil of Ingres. His colour does not beautify or soften, it is opposed to all

sham, and determined not to simulate the appearance of reality. The unreal elements are made visible by Degas. His structures can lay claim to the term anatomy, but composed out of visionary skeletons. There is something like the wings of tropical butterflies in the depths and chasms of his work, and in their dust sunlight lies concealed, as in the spotted tongues of twisted orchids. His blues, purples, violets, his orange, his greens, and his pink, are like exotic plants, a decomposing process supplies the rare tone of his colours. His decoration modifies and heightens these effects, which have grown in extent and are now capable of swallowing up all that was petty in his earlier work. Where should we find room now for his old pettiness? The milieu of powder-puffs and pots of rouge disappears into a lower world. It is succeeded by a stage innocent of all superfluous furniture, which has waves of colour instead of wings. It is only now that the mechanism of the motion he presents gives expression to his gestures, which, in his earlier work, were lost in a space that was empty of air. He now makes open mouths and stretched-out limbs into the cup-bearers of a new glory. His parallel structures of rows of limbs gain a multiplied force; the repetition is necessary in order to enable us to bear the power of the type. There are pastels of *danseuses* which make on us an impression similar to fragments of enormous friezes. We can imagine the Parthenon decorated in this way. His dancers cease to be mere ballerinas, just as the ancient warriors in the Parthenon frieze have surrendered their objectivity and have become the servitors of divinity. The four laths of the frame round the creations of our contemporary add to their mystery. There are three large pastels in the collection of Durand-Ruel, each with three dancers in different attitudes. One of them is pink, fiery red and emerald green; the second blue, purple and light green; the third orange and purple; that is to say, they are all quite different. They do not hang side by side in the collection, they are separated by pictures by Renoir and others. Nevertheless, they take complete possession of the room. If you half close your eyes each one of them seems to grow. The dancers multiply and embrace one another, the silence grows and the whole room reverberates to the beat of their dance, and at the same time you see hardly anything of a real dance or of real dancers in these pictures. They are more akin to coloured expressions than to human beings. Their flesh—that which one has to regard as flesh—consists of abnormal pores resembling the rind of trees in a primeval forest. Their clothes are like the scales of lizards. You can find no human

comparison, and yet the exotic glory of their colour plays only a small part in the queer impression these pictures create. The colour is just sublime enough to decorate their expressions, and it is their expressions which are so moving. They become familiar to the eye without being distinguishable, and the usual mental reactions are absent. The element with which the observer becomes familiar is the soullessness of the expressions, in which we recognise something of our own. The glory of it all gives a sense of hierarchic festivity to the delight we experience.

 THE last decade of Degas' labours—he did not work during the last years of his life—marked yet another step in his evolution. In the painter's youth his draughtsmanship predominated at the cost of his colour, thereby preventing the attainment of harmony. In his pastels, in the best of them, design and colour are inseparable, and his vision was perfect. All difficulties are resolved by the power of his colour. In his final period his colour is relegated once more to a secondary place. His last pastels do not possess the fabulous glory of the drawings, which date from the end of the 'eighties and the beginning of the 'nineties. They are drawings which are decorated only sparingly here and there with a touch of colour, but the criticism to which he had once been open, of faulty distribution, is silenced. The expression which he gives us with the strokes of his charcoal could not be heightened by any pigment or the application of any other technique, however skilful. The quality of colour is suggested by the wealth of his design. We accept the few patches of green or yellow or red which we see side by side with the black of his design, and just as we accept the remains of pigment which once covered the whole surface of the work of an old master, we delight in the charm of what is left, but we think no more about it. The power of the design swallows them up and the simplicity of the Degas of this period triumphs over his richest symphonies. We are grateful that he has given us the work of the 'eighties and 'nineties as well. Perhaps we needed the charm of his fairy-like stage in order to follow and appreciate him during his last period, but seen from the later

La Leçon de Ballet. Charcoal heightened with color, 1895–1900.

Les Repasseuses. Oil, ca. 1884.

standpoint, his stage loses something of its glamour. His gayest pastels appear, by the side of his last designs, like the bearers of a draught which intoxicated and confused us, but here in his ripest work we are aware of a heightened sense of reality.

Not long ago, Vollard possessed a series of pastels and drawings which covered a period from 1895 to 1905. The dancers are nude. There is a *Danseuse à la Barre* among them in almost exactly the same attitude as the *danseuse* on the right of the famous picture in the collection of Rouart. In this collection there was also a *Répétition de Danse* with nude figures in their well-known attitudes, and it contained one of those groups of dancers, which in his pictures are often found standing near the wings, in this case naked. For all its glamour we miss much of Degas' elegance. The old man's hand had lost some of its agility, his eye was less acute, and his delight in his subject had grown weaker. The nudity of the figures has something of the barrenness of an old man. We feel many hard touches in the picture, and there is something incomplete and fragmentary which disturbs us. We feel the brittleness of a temperament, which has suffered in its struggle against much opposition, and we guess the poverty of a soul which never knew any real joy, but even in the barrenness there speaks the pride of a man who finds the world no longer worthy to be the spectator of his proud drama. We are reminded of an impenitent sinner in sackcloth and ashes. The rough strokes of his charcoal are placed on the bodies of the women, who once tempted him, like the weals of chastisement. Rembrandt found in his failing old age the means to reveal his sublimest powers.

The moderate pictures of his early times are famous; the best products of his maturity are unknown. I can remember seeing a large picture of dancers in Degas' studio in the 'nineties. The charcoal drawing, heightened in colour, of four or five nude half figures in the Vollard Collection belongs to the same series. Vollard's drawing was probably produced a little later—at any rate, it looks like an extract of the painted picture. The group teems with heads and arms, placed one above another, a wealth of painted limbs and jagged profiles. There is nothing soft or rounded in the detail, no attempt at fair phrases. It is like a mason's work, and it is wonderful how the rhythm of the composition dominates these pointed arches and jagged edges, how the bold curves of the bodies stand out in this blur of motion, how one body seems to grow out of the entanglement of many, how the whole thing has become a mysterious, trembling, swaying mass;

a piece of decoration full of the mystery of architectural expressions, like the cathedrals of a bygone age, in which mosaic saints, between columns and pointed arches, seem to question, and glowing windows framed by the structure of the masonry murmur their answer. Architecture freed from all foibles of style. No single component part is sacrificed to the general abstraction. The series of figures recede into the depth of the picture and present simultaneously a flat design; thus Degas overcame the errors in his literary pictures, which were mere gaps in the surface of nature.

The series of figures is not needed. One body suffices to convey space and volume of the greatest possible variety. The large drawing of the girl combing her hair, in the von Friedländer Collection in Berlin, seems to grow out of the motion of its own curve. The girl is really combing her hair, despite the fact that she looks like a creature who has dropped from a distant star, and yet she combs her hair like every other woman, although the representation is not in any way realistic.

The glamour of the goal Degas set for himself gilds his struggle to attain it. The imperfect products of the erring and struggling Degas have acquired something of the halo of his greatness, like the too finished pictures of the 'seventies whose perfection never attained to the greatness of his fragments. As we look back we seem to find in many pictures where his tendency to genre predominated, a certain preparation for his maturity. Countless dancers and jockeys acquire relevance and import by virtue of our contemplation of his masterpieces. They played a part in the development of the type Degas created. The two flatly painted washerwomen with their baskets, of 1897, two congruous though contrasting figures, represent a milestone on the path Degas followed, before he arrived at a modern form of the decoration of flat spaces. His series of *Ironers* contains similar signposts. In the picture in the Durand-Ruel Collection, which is said to date from 1882, the reticence of his style goes beyond the confines of his old realism. The two women have ironed the shirts in front of them throughout many centuries. The great frieze of dancers in the collection of Max Liebermann already displays a very unusual quality of decoration.

This peculiarity of his art reveals his last foible. At the most important turning-point in his career Degas was faced by the universal alternative: naturalism or the sham of the decorator. This alternative was a problem which faced all the masters of his day, at the

time when impressionism was liberated from its traditions. Only decoration could prevent painters, who were running after physiological phantoms, from resolving their work entirely into coloured patches, and this method seemed, at that moment, as great a discovery as that of the light of the sun. The landscape painters who belonged to Monet's circle were held back by their tenacity to Monet's doctrines. They lacked the lines with which to construct the necessary scaffolding for such decoration, and their pantheism forbade them to search for it. Renoir and Cézanne, both of them more agile, had to go through a hard struggle when they faced this problem. The power of their vision carried them to victory. For a man like Degas his line was both his point of departure and his result, and for this reason, this narrowly-defined problem has seldom attracted anyone as much as it did him. The old man realised the danger and renounced his riotous colour, but he added a monumental element to his decoration. His last attempt was to scale the highest pinnacle. His reach exceeded his grasp. How could the art of such a man, without a god, no matter how purified and disciplined he had become, lay the foundation of the holiest temple!

In the whole range of his work there is much renunciation, much searching, much straying, and it ends as it began. A few black lines contained the hidden promise of the Ingres pupil, and a few black lines reveal his perfection, but even his perfection is only the promise of something greater. It is the attempt to extend his grasp beyond his reach. Is the result great or small by the side of his contemporaries? The question is answered before it is put. Above all, he is different. Degas, the outsider, accomplished everything that intellect and will power can achieve. The mature growth of a healthy, if fragile, constitution was denied him, because the world he created did not possess a normal climate, blessed by changing seasons. The gain to the individual details narrowed the scope of his work. The continual strain of his efforts cramped him as time went on.

In Degas, the man, we feel the likeness to an old master. He acted and he looked like one. He possessed a distinction which was noble. His premature fame, which differentiates him from all the other masters of his day, never altered his behaviour or his manner. He remained in the background, not so much from modesty as from pride, because his incorruptible insight convinced him of the insufficiency of popular approbation. His self-criticism was as fanatical as his judgment of his fellow men. When he was an old man

he did everything in his power to gain possession of his early works, and he would stick at nothing to destroy or retain any of them which were incapable of improvement. An acquaintance of his walked up to him at the Vente Rouart to congratulate him upon his unparalleled success, and was rewarded for his trouble by Degas' bitterest irony. The demands of a noblesse, which was almost diseased in its development, frightened men away from him. Degas himself carried out the demands which his noblesse made upon him, in an exemplary existence. The unsullied shield of honour of an old master is thus held by an artist who was entirely dependent upon the modern age. Herein lies his tragedy. He hated his age because he felt its mark upon his brow, and because his fellows chose to honour him, and none other, as the destroyer of the past. Degas, far more than his contemporaries, stands for innovation. Novelty is always fragmentary or transitional. In Manet and Renoir, and even in Cézanne, who was the most consequent of them all, tradition always predominates over novelty. Everything old and everything new is in them. The farther we penetrate into their work the more do we find the traditional element, whereas by the same process we find less and less tradition in the work of Degas, who clung to it passionately. He was destined to fight against that which provided a home and shelter to others, and thus he lost the blessing of the innovator who by his own genius aids his fellows. Degas discovered the absolute novum of his age. In the case of Manet and Renoir we can say: That is what we would like to be. Cézanne managed to preserve a remnant of the idealism of Delacroix in his mysticism. In the case of Degas we have to confess: That is what we are, and in saying this we do not refer to his aim, but to his style. The penetration he brings to bear upon our nakedness is a part of ourselves. His confessions stand before us as remorseless as the straight lines, which Delacroix resisted, which Baudelaire regretfully foresaw when he praised Delacroix, and which were the means of Degas' victory.

Degas opened the way for a new era in art. At the foot of the monument, which should be erected to him, we will find the strange figures of Forain and Lautrec, van Gogh and Gauguin, surrounded by many others. Picasso and other living oddities would be among the crowd. Some of them derived from Degas the rapid shorthand of the prose which they used to write the journal of the Paris that they knew. Actuality was the boundary of their limitations, the others—and sometimes they were the same—generalised upon the straightened

structures and forged from the icy intensity of Degas, the despiser, a
new and fervid symbolism. Mighty treasures have resulted from this
process. Who could fail to be spellbound by the *Arlésienne* of van
Gogh, who almost succeeded in creating a new image of saints, van
Gogh who clamoured passionately to Daumier and Delacroix to save
him from the novelty of Degas' consuming flame? Who could resist
the temptation of Gauguin's mysticism? But not one of his successors
overcame altogether the barrenness of the style to which Degas gave
birth. We must sift them severely, as Degas himself did. His legacy is
flat and linear. Directly or indirectly, every form of decoration which
is not archaic owes something to Degas. One day, when our passion
for decoration is recognised as fictitious, someone will commit the
injustice of reproaching the loneliest of the masters of our time, who
hated the profanity of the plebs, with devoting his energies to the
masses. This is another aspect of his tragedy, just as it is the tragedy of
van Gogh not to be understood by the simple and poor, upon whom
he placed his hopes of the rebirth of humanity, for he will one day be
accused, though his work is fuller of human love than that of most
men, of having laboured only for the edification of snobs. A Degas,
like the steam-engine, had to come one day. He was the strictest
conserver of our old traditions, and he became their most destructive
annihilator. We are still amazed at the strangeness of his genesis. His
rigidity still holds the palm for scepticism and renunciation, and is
surrounded by the halo of self-abnegation. We see already a new form
of artistic expression rising from the barren soil in which Degas
sowed, and on it classicism is taking its belated revenge for the
faithlessness of the Ingres pupil. The result is a new academicianship,
whose shortsightedness is suppressing what is left to us of the past,
and substituting for it mechanical design.